KENT'S
LITERARY HERITAGE

MARGARET WOODHAMS

AMBERLEY

First published 2023

Amberley Publishing
The Hill, Stroud
Gloucestershire, GL5 4EP

www.amberley-books.com

Copyright © Margaret Woodhams, 2023

The right of Margaret Woodhams to be identified
as the Author of this work has been asserted in
accordance with the Copyrights, Designs and Patents
Act 1988.

ISBN 978 1 3981 1061 8 (print)
ISBN 978 1 3981 1062 5 (ebook)

British Library Cataloguing in Publication Data.
A catalogue record for this book is available from the
British Library.

Typesetting by SJmagic DESIGN SERVICES, India.
Printed in Great Britain.

Contents

1. In the Beginning

After spending three years conquering Gaul (modern-day France), Julius Caesar turned his attentions to Britain in 55 BC, although he did little more than land on the shores of Kent before heading back across the Channel. He came back the next year, later describing Kent's inhabitants as 'the most civilised' of Britons, 'differing but little from the Gallic manner of life'. Despite this rather backhanded compliment in his *Gallic* Wars, the island at the northern edge of the Roman Empire is rarely mentioned again in records and nothing in the way of home-grown literature was produced, despite the centuries of occupation following Claudius' more decisive invasion of AD 43.

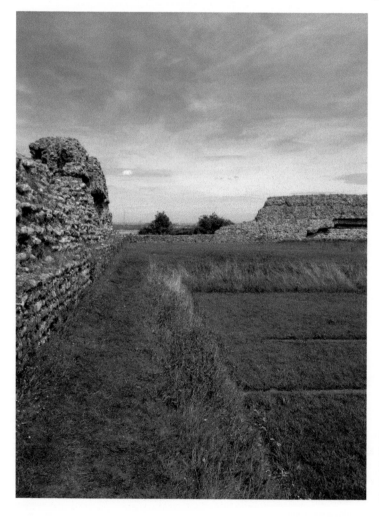

Now 2 miles inland, Richborough near Sandwich was once on the coast and its Roman remains date from AD 43.

When Rome's legions finally departed in 410, Kent once again found itself on the front line of invading forces, this time in the shape of the Germanic tribes of Angles, Saxons, and Jutes. They brought with them their various dialects which in time came together in a language now known as Anglo-Saxon or Old English, which both looks and sounds quite different to the English of today.

Original texts from the Anglo-Saxon period are understandably rare but there are a number produced in Kent that are of considerable significance, including The *Vespasian Psalter*. This late eighth-century illuminated book of psalms is written in Latin, accompanied by an Old English glossary, making it the oldest English translation of any section of the Bible.

Kent itself features in *Historia Brittonum, c.* 830, attributed to the Welsh monk, Nennius. It tells of two warrior brothers, Hengist and Horsa, who land on the Isle of Thanet in 449, as mercenaries in the service of Vortigern, King of the Britons. At a feast attended by both Britons and Anglo-Saxons, Hengist instructs his daughter to ply Vortigern with as much drink as she can. So successful is she that before the feast is over, the inebriated king

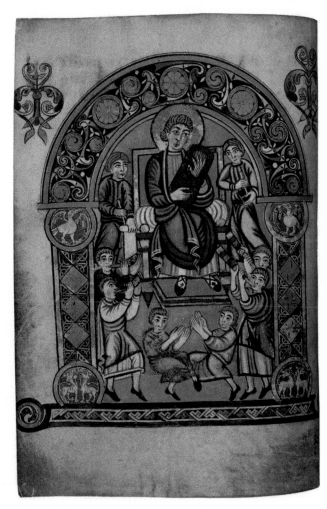

Distinctive stylistic features indicate the *Vespasian Psalter* was created by scribes at either St Augustine's or Christ Church Priory in Canterbury. (BM MS Vespasian A1f021v)

promises Hengist anything he desires providing he, Vortigern, can marry the girl. Hengist promptly demands the whole of what subsequently becomes the Kingdom of Kent, thus providing himself with a stable power base from which to launch further land-grabbing raids.

Geoffrey of Monmouth's factually dubious *Historia Regium Britanniae, c.* 1138, embroiders the tale. Hengist's daughter, here called Rowena, is unpopular with the Britons, who revolt against Vortigern, placing his son, Vortimer, upon the throne. Rowena regains the kingdom for her husband by poisoning the unfortunate Vortimer; her triumph is brief, however, when her father's forces systematically take control of Kent, wiping out the Britons as they go. Rowena, it has been suggested, may be an archetype for all those wicked stepmothers and seductresses who have woven their way through literature ever since.

Although not himself based in Kent, the monk Aelfric (950–*c.* 1010) wrote several religious texts – which were clearly known to the monks of Canterbury's Christ Church Priory, as their scriptorium produced a Latin translation of his work *Colloquy* – during the late eleventh and early twelfth centuries. *Colloquy* is significant as it takes the form of a dialogue between a teacher and a group of novice monks, drawn from all levels of Anglo-Saxon society. The depictions of such characters as a lawyer, a cook, a hunter, and a tanner provide a rare insight into the lives of ordinary people of the time. The text again comes with an Old English glossary, perhaps suggesting a certain

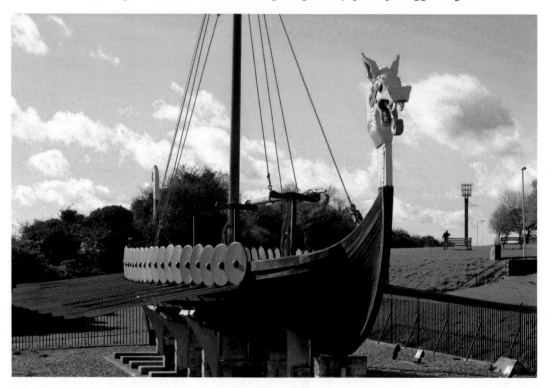

The Hugin in Pegwell Bay is a reconstructed longship gifted by the Danish government in 1949 to mark the 1500th anniversary of Hengist and Horsa landing in Kent.

reluctance amongst the scribes of a Kentish monastery to adopt the language of the latest wave of invaders, the Normans, who had taken power in 1066 under William the Conqueror.

One of the most remarkable of all documents written in English is the *Textus Roffensis* created in England's second oldest cathedral, Rochester, between 1122 and 1124. Like Canterbury it boasted a fine priory and scriptorium. Transcribed in the priory, some 500 years after the original contents were written, in a distinctive script known pleasingly as Rochester Prickly, the first half of the volume consists of the oldest Anglo-Saxon prose text in existence.

The text contains those crimes punishable by law in the court of Kent's King Ethelbert, the ruler who welcomed Augustine to the county in 597 at the start of his mission to spread Roman Christianity in Britain. Amongst an extensive list of the compensation deemed appropriate for a given offence we discover that gouging out an eye would have cost the perpetrator fifty shillings, whilst stabbing a man through his genitals would, somewhat surprisingly, only have cost the culprit six shillings. The text also contains King Alfred's lawbook and this emphasis on justice and order has led to it being described as the precursor to the much later Magna Carta of 1215.

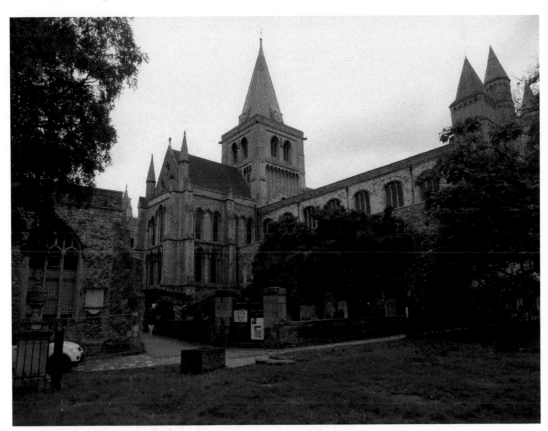

Rochester Cathedral has been a place of Christian worship since 604.

Left: An Anglo-Saxon scribe at work.

Below: Statues of Ethelbert and Bertha on Lady Wootton's Green, Canterbury.

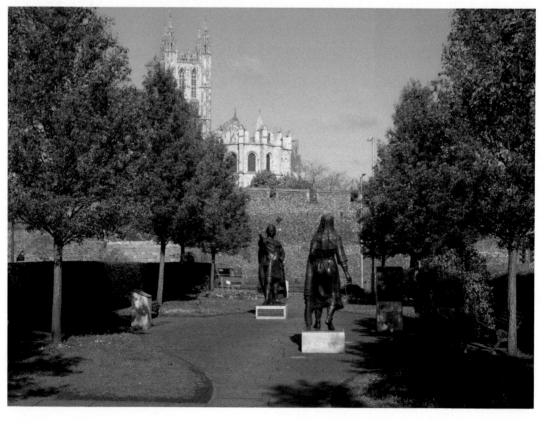

2. Medieval Minds

In the years after the Conquest, written Old English was forced to give way to French and Latin, the languages of the upper classes and of Norman authority in general. These were the languages, therefore, of the law courts, of administration, and of the Church. Spoken English was far more tenacious, however. Another important text linked to Rochester's scriptorium shows how spoken Norman French and Anglo-Saxon began gradually to amalgamate, in the transcript of a sermon delivered by Archbishop Ralph d'Escures, who had taken office in 1108. He ordered not only Latin copies of his sermon but also a copy in what linguists have labelled as the first written example of this merging of two separate languages into one.

By the mid-1300s, regardless of social status, most people spoke in that merged language, today called Middle English. In 1362, for the first time, Parliament was conducted in English and during that same year, it became the official language of law courts. It was still regarded as of low literary merit compared to French and Latin but despite this, one young man in service with the King's son, Lionel, decided that his poetry would be written in the London dialect he himself spoke. His name was Geoffrey Chaucer (1343–1400), and it is with him that English literature as we understand it really begins.

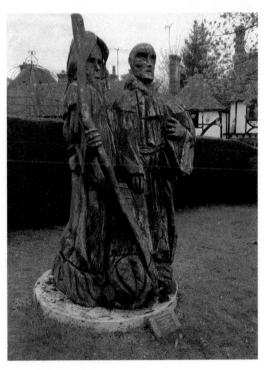

A sculpture of Canterbury Pilgrims at Chilham.

His influence on English and its literature is profound. The Oxford English Dictionary credits Chaucer with the first written use of over 2,000 words now commonplace in English, including *bagpipe, accident, scissors, village, theatre, princess,* and *femininity.* Poems such as *Troilus and Criseyde, Parlement of Foules* and *The Legend of Good Women* are written in rhyming couplets with five stresses in each line; an innovative verse form at the time that went on to become a standard of English poetry.

Chaucer spent his life in the service of the Crown and in 1385 he became Kent's Justice of the Peace, a role he occupied until 1389. He was also Kent's member of Parliament in 1386, so it is reasonable to assume that he was familiar with the county. Although there are no definitive records of the visits he must have made, he will forever be inextricably linked to Canterbury, through his lengthy narrative poem *The Canterbury Tales,* begun around 1377. In 1170, Archbishop Thomas Becket had been murdered in Canterbury Cathedral by four of Henry II's knights and his shrine there had become one of the great pilgrimage destinations of medieval Europe.

In the poem, a group of disparate pilgrims from a variety of social backgrounds set off from London to visit Canterbury, *'The hooly, blissful martir for to seke'.* They agree to a story-telling competition to help pass the time with the best tale to be awarded a prize when the pilgrimage is over. Whether it is the cynical Merchant's account of an old

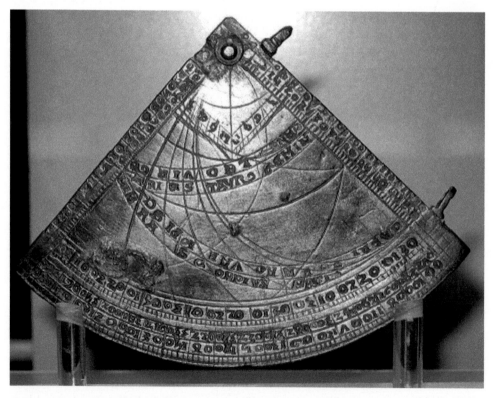

Chaucer also wrote in prose and his treatise on the use of the astrolabe is generally regarded as the first scientific treatise written in English. An extremely rare example of this astronomical device was excavated in Canterbury in 2005 and is now in the British Museum. (Photograph by Jack1956)

Canterbury Cathedral's Trinity Chapel housed Becket's magnificent tomb, destroyed in 1538 when Henry VIII ordered the Dissolution of the Monasteries.

man whose wife is unfaithful to him in the branches of a pear tree, the Pardoner's tale of three stupid young men searching for Death or the Wife of Bath's lively narrative of a dishonoured knight sent on a quest to find out what it is that women most desire, these satirical, witty, and bawdy stories are as appealing to modern readers as they were to those who first heard them 600 years ago.

Earlier in his career, Chaucer had been sent on a diplomatic mission to Italy. He gave power of attorney over his affairs back home to his friend and fellow poet, John Gower. Gower's early works are in Latin and French, but inspired by Chaucer, he also began to write in English; various dialect words he uses have led scholars to believe he was from Kent. His work *Confessio Amantis* is a 33,000-line poem in the form of an extremely long confession. Despite his importance as one of the first writers to write in English, Gower's work falls far short of Chaucer's. Whilst the great medievalist C. S. Lewis praises him, many others have described his poetry as extremely dull.

Although not primarily a writer himself, William Caxton (*c.* 1422–*c.* 1491) is vital to the history of English literature, as it was he who set up the country's first ever printing press. His exact birthplace in Kent is disputed, with Tonbridge, Hadlow and Tenterden all claiming the honour. Wherever he grew up, much of Caxton's adult life was spent

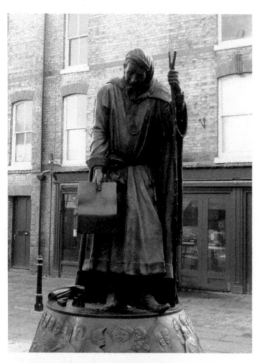

Left: In 2016, a 2-metre-high statue of Chaucer was unveiled in Canterbury, with thirty characters from *The Canterbury Tales* depicted on the plinth.

Below: Tenterden clearly has little doubt as to the great man's origins.

travelling and living abroad as a silk merchant. Visiting Cologne, he observed one of the newly invented printing presses at work and inspired by the possibilities of this new technology, he established his own press on returning home to Bruges. In 1473, the first book in English ever printed appeared – Caxton's own translation of *Recuyell of the Historyes of Troye*, a collection of stories associated with *The Iliad*.

His Bruges venture proved so successful that Caxton decided to set up shop back in England where, by 'the sign of the Red Pole' near Westminster Abbey, he became the first person in the country to sell printed books, 80 per cent of them in English. The first title to roll off the press in that year of 1476 was *The Canterbury Tales*.

Printed material required a gradual standardisation of spelling, vocabulary, and grammar, creating a widening gap between accepted written forms of English and its many spoken regional variations. Caxton said his own speech was 'that of Kent in the Weald, where I doubt not is spoken as broad and rude English as any place of England'. Caxton translated many of the works he published, so inevitably his Kentish English came to have a significant influence upon the standardised written form of the language.

Archbishop of Canterbury for twenty years under three Tudor monarchs, Thomas Cranmer (1489–1556) also helped to spread the use of written English, through his work on the *Book of Common Prayer*, the first edition of which appeared in 1549, during the reign of the fiercely Protestant Edward VI. For the first time, people could pray and follow the liturgy in English rather than the Latin of Catholic worship. It is uncertain how much Cranmer himself wrote of the book, but he is certainly responsible for its structure and the nature of its contents.

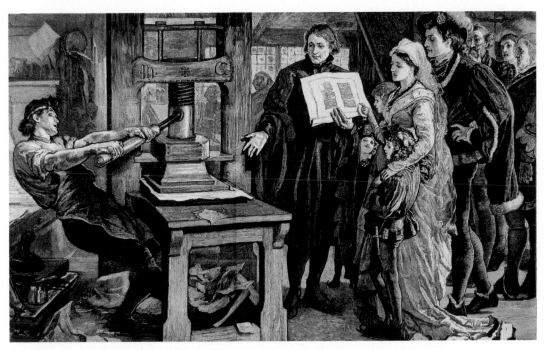

Caxton showing his printworks to King Edward IV and Queen Elizabeth. (*The Graphic* 1877, author unknown)

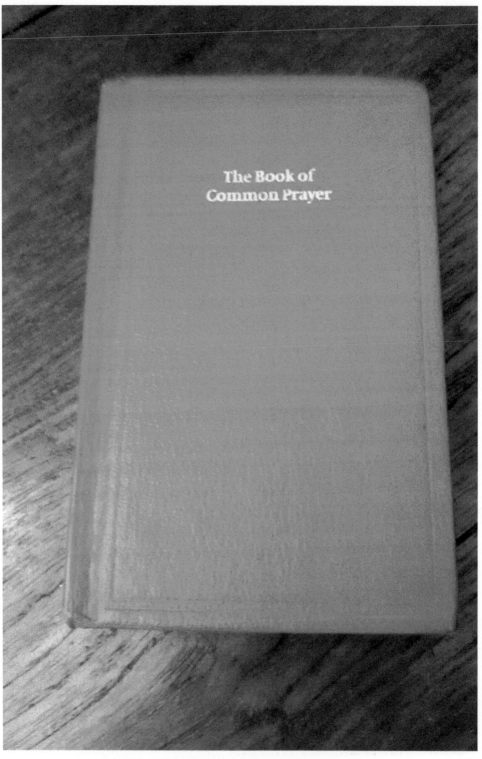

The Book of Common Prayer changed the way in which the English could worship.

3. Renaissance Writings

Medieval drama had consisted primarily of mystery plays, intended to bring Biblical stories to life for a largely illiterate majority. The themes of these plays were necessarily limited and although undoubtedly entertaining, the characters were stereotypical and one-dimensional. During the fourteenth and fifteenth centuries, as Renaissance thought spread to Britain from Europe, English drama experienced an astonishing flowering as it sought to reflect exciting new ideas about politics, philosophy, history, science, and the arts. Kent and its writers were at the heart of these changes.

The earliest example of a play moving from mystery to history is *King John*, written in 1538 by John Bale (1495–1563), a fervent supporter of the religious reforms of the time. First performed at Thomas Cromwell's house, the play is anti-Catholic and celebrates King John defying Rome in a manner guaranteed to appeal to Protestant sensibilities. Allegorical characters such as Sedition, Private Wealth and Usurped Power convey the story in familiar medieval style, but they appear alongside characters who are recognisably themselves, including John and King Henry VIII. This marks a clear transition from one style to another. Bale is also remembered for having written what is regarded as the first ever history of English literature, entitled *A Summary of the Famous Writers of Great Britain*, published in 1548.

Neither his literary nor his religious achievements seem to have endeared him to others. During a brief spell as Bishop of Ossory in Ireland from 1552 to 1553, he acquired the nickname 'bilious Bale'; one can only hope that he had mellowed by the time he came to Canterbury Cathedral as a canon in 1560.

Canterbury was also familiar to John Lyly (1553–1606). His father was employed by Archbishop Parker and Lyly attended the King's School before attending Magdalen College, Oxford. He became secretary to Edward de Vere, 17th Earl of Oxford, but by 1578, he had become famous beyond the confines of de Vere's household thanks to the popularity of his book *Euphues or the Anatomy of Wit*. The work is a cross between a romance and a travelogue and was an instant success; it was followed by the equally successful *Euphues and His England* in 1580. They are notable for their use of convoluted grammar, excessive alliteration and figurative language in a style that became known as euphuism.

De Vere, himself a playwright, was instrumental in helping his renowned employee gain control of Blackfriars Theatre where, between 1584 and 1592, he wrote and directed at least seven plays, acted by the boys' company of St Paul's, all of which were extremely successful. The Queen was said to have much enjoyed his work although she never rewarded him with a coveted position at court despite the many letters he sent complaining that he had been *'Thirteen years your highness' servant'* and received *'but nothing'* in return. As euphuism fell out of fashion, Lyly's fortunes declined, his work

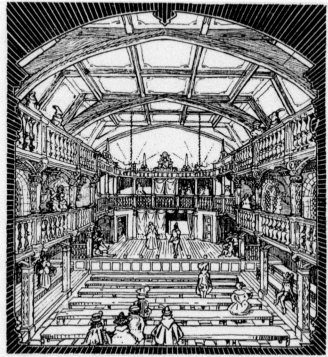

CONJECTURAL RECONSTRUCTION *by G. Topham Forrest*

Above: Bale lived the last years of his life in Meister Omer's house, now a King's School boarding house.

Left: 'Blackfriars Theatre; Conjectural Reconstruction' by G. Topham Forrest. (*The Times*, 1921)

forgotten. His plays are seldom performed today although *Endymion* was staged by the University of Kent in 2012.

He deserves to be better known for many scholars because for many scholars he was instrumental in carrying on the process begun by Bale before him. In plays such as *Endymion* (1588) multi-faceted characters speak in lively, if elaborate, prose, and operate within well-considered plots, far wider in their range and appeal than the narrow confines of medieval religious drama. His influence on fellow dramatists is obvious; for example, Shakespeare's *A Midsummer Night's Dream* is clearly drawing upon Lyly's *Gallathea*, and the use of clowns and comic sub-plots in plays such as *Twelfth Night* are inspired by similar devices in Lyly.

If Lyly is under-appreciated, the same cannot be said for another King's School boy, Christopher Marlowe (1564–93), who has a place in the literary canon denied his older contemporary. Marlowe's father, John, was a Canterbury shoemaker, so when his son was christened in the city's St George's Church a few days after his birth, an illustrious future would have seemed unlikely. Fortunately for the boy, he lived in a city where education was available to those of humbler means, and it is thought likely that he spent his early years at the school for poor scholars that had been established in Eastbridge Hospital by Archbishop Parker in the years after the Reformation.

Eastbridge Hospital in Canterbury was once accommodation for poor medieval pilgrims.

In 1578, he became a pupil at King's School where his fees may have been met by local philanthropist Sir Roger Manwood, whose death in 1592 Marlowe marked by writing a Latin eulogy. Whilst at King's, Marlowe received the finest education of the day, the emphasis being upon the learning of the Classics. Indeed, the boys were expected to speak to one another at all times in Latin, even during leisure activities. One popular pastime at the school in which Marlowe would have participated was the performance of plays in Greek and Latin, complete with an array of costumes and props.

At the age of sixteen, Marlowe was awarded a scholarship to Corpus Christi College in Cambridge where he soon began writing his own plays, no doubt drawing upon what he had learned during those school-boy productions. He gained his BA in 1584 and began studying for his MA, seemingly bound for the Church, a requirement of his scholarship. Marlowe was never to be ordained, however, as the State had something else in mind for him. Elizabeth I's Chief Minister was Lord Burghley, who was also Chancellor of Cambridge University during Marlowe's time there. Burghley used his position to recruit the brightest students to act as secret agents in the spy network run by Francis Walsingham. This was a period when the Protestant Elizabeth was under constant threat of assassination by Catholic enemies and Walsingham's spies were everywhere, seeking out plots and conspiracies.

College record books show that Marlowe was often inexplicably absent from Cambridge, so much so that the authorities were reluctant to grant him his MA. They relented when a letter from the Privy Council dated 29 June 1587 explained that he had been employed 'in matters touching the benefit of his country' and should not be disadvantaged by 'those that are ignorant on th'affairs he went about'. Whilst it leaves the exact details of Marlowe's employment tantalisingly secret, that he was working for Walsingham seems almost certain.

On leaving Cambridge, from 1587 onwards he was based mainly in London concentrating on writing the plays that have secured his place in the history of English drama. During his university studies, he spent much time translating Latin texts into a form of poetry known as blank verse – lines of ten syllables employing a stressed/unstressed metre, ideal for speaking aloud as it replicates the natural rhythms of English speech. *Tamburlaine* is the first play in English written using this form and Marlowe's innovative use of poetry and drama is often regarded as informing the style of his contemporaries, including Shakespeare. *The Jew of Malta* is described as the first successful English tragic-comedy and surely served as inspiration for *The Merchant of Venice*. *Edward II*, with its flawed and all too human monarch, is an obvious forerunner of Shakespeare's kings in plays such as *Richard III*, *Henry V* and *King Lear*.

Dr Faustus is probably the best known of his plays, in which the eponymous hero is an arrogant scholar who claims to have mastered every subject he has ever studied. Looking for greater challenges, he uses magic to conjure up the devil's messenger, Mephistopheles. The two strike a bargain whereby the Devil tells Faustus he 'will spare him for four and twenty years/Letting him live in all voluptuousness', after which his soul will be forfeit. In his hubris, Faustus agrees. The scene where the Devil finally comes to collect his debt is both powerful and terrifying, so much so that its early audiences were often 'distracted with that fearful sight'.

In May 1593, at the age of twenty-nine and at the height of his dramatic powers, Marlowe disappeared from the stage and from any official records. His passing was lamented by contemporary writers although the manner of his death remained a mystery until 1925 when an account was found in the Public Records Office of an inquest in 1593, outlining a brawl in a Deptford tavern during which Marlowe was fatally stabbed.

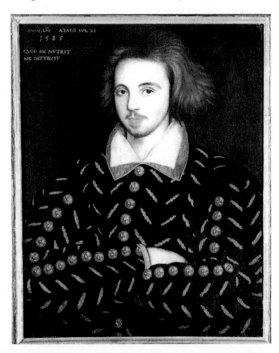

Right: Portrait of an unnamed man supposed to be Marlowe. (Corpus Christi College, Cambridge, artist unknown)

Below: In 2011, the third theatre in Canterbury to be called The Marlowe opened its doors.

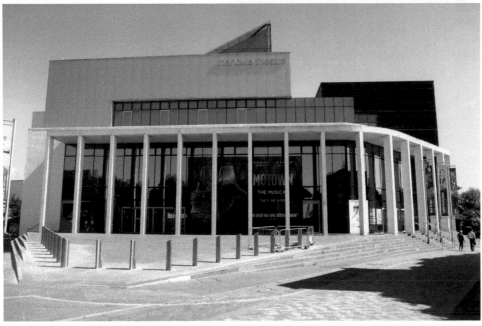

Although the greatest dramatist of them all, William Shakespeare (1554–1616), never lived in Kent, it is likely that he paid it more than one visit. Throughout his career as both writer and actor, he had associations with several of the actors' companies who performed in London's theatres. Periodic outbreaks of plague forced the closure of the playhouses, leaving the players obliged to take their shows on the road, with Kent being a popular destination. In 1592, records show that *'my Lordes Stranges players'* with whom Shakespeare was working at the time were entertaining audiences in Maidstone at a cost of 20 shillings to the local authorities. By 1597, Shakespeare had links to the Lord Chamberlain's Men who visited Dover and Faversham in that year. In 1605/6, they were back in Kent and are known to have visited the tiny town of Fordwich, just outside Canterbury. Here they would have performed either in the open air or in the town hall.

Kent appears in several of his plays. In *King Lear*, Edgar and poor blinded Gloucester stand high atop the cliffs at Dover. In *Henry VI part 2*, Lord Say praises Kent as 'the civil'st place of all this isle/Sweet in the country, because full of riches/The people liberal, valiant, active, wealthy'. In *Henry IV part 1*, Poins reminds his companions that 'tomorrow morning by four o'clock early, at Gads Hill, there are pilgrims going to Canterbury with rich offerings'. Gads Hill, near Chatham, remained a popular spot with highway robbers until the nineteenth century, by which time its reputation had improved sufficiently for Charles Dickens to make it his home.

The perfectly preserved Fordwich Town Hall is one of the very few existing places to have witnessed a performance of Shakespeare's plays during his lifetime, possibly in his presence.

In a case of literature informing landscape, a section of Kent's famous chalk coastline has been known as 'Shakespeare's Cliffs' for many years.

The year before Marlowe's death, in 1592, a play entitled *Arden of Feversham* was published anonymously. It tells the story of the actual murder of Thomas Arden, the mayor of Faversham, in 1551. At the start of the play, Arden complains to his companion Mosbie that 'all the knights and gentlemen of Kent' are talking of his wife's infidelity, but Mosbie assures him that it is just gossip which should be ignored. Both in real life and in the play, it turns out that Arden really should have listened to the rumours as the lovers decide to do away with him and hire two well-named thugs, Black Will and Shakebag, to carry out his murder. This is done in brutal and bloody fashion, but the rogues are speedily apprehended and brought to justice. Alice and Mosbie are also tried and executed when their role in the grisly deed is discovered.

The authorship of this true crime drama has never been agreed upon. It is most often attributed to Marlowe, and as a local man, he cannot fail to have known about the notorious murder. Thomas Kyd and Shakespeare have also been mooted as possible authors, and it has even been suggested that it may have been a collaborative effort between all three writers. Whoever wrote it, the play is important as it is the earliest surviving example of a domestic tragedy, one in which the protagonists are not necessarily high-ranking, but humbler individuals caught up in terrible events.

If drama was being changed for ever by Kentish writers during this period, then so too was poetry. Born in Allington Castle, north of Maidstone, Thomas Wyatt (1503–42) is one

Arden's Faversham home still stands and the play itself is revived regularly, with the RSC staging a run in 2014.

of the most important poets of the Tudor era. As an ambassador at Henry VIII's court, in 1527 his duties took him to Italy, where he became fascinated by the poetry of that country and the impact of new humanist ideas upon literature. He was a highly educated man and on his return to England, it became his express wish to energise English poetry, so that it could rival what he had found in Europe.

He had long admired Chaucer and when in Italy, had been inspired by the work of another fourteenth-century poet, Petrarch. He translated many of Petrarch's poems into English, thus producing the first sonnets ever to appear in the language. These fourteen-line poems became a staple of English poetry thereafter, and the changes Wyatt introduced to the conventional Italian rhyme scheme and the development of the final rhyming couplet marked the start of what became a distinctive English sonnet form. Wyatt is among the first English poets to draw upon his personal experiences; whilst his poems may make use of traditional verse forms, they serve as a vehicle for Wyatt's own emotions and thoughts, which was something new in English poetry. In *Farewell Love and all thy Laws for ever*, for example, he bids love 'go trouble younger hearts/And in me claim no more authorite'.

Wyatt is also famous for his association with Anne Boleyn, the King's second wife – Wyatt was amongst those unlucky men rounded up by Henry VIII as he strove to rid himself of Anne in 1536, by accusing her of multiple affairs. Imprisoned despite the lack of any evidence suggesting an improper relationship with Anne, he was eventually

released only to be re-imprisoned in 1541 for apparently not having served the King's interests to the best of his ability. He was once again pardoned but died the following year whilst escorting the French ambassador from Cornwall to London, doubtless exhausted from the perils of working for the increasingly tyrannical Henry.

Another of Henry's courtiers who suffered at his hands was Sir Thomas More (1478–1535), who became Lord Chancellor in 1529; the timing could not have been worse. Henry had tired of his wife, Catherine of Aragon, and was seeking a divorce so that he could marry the aforementioned Anne Boleyn. More would not support the King in his divorce or in his subsequent break with the Pope and paid the price for it when he was beheaded in 1535.

More was a scholar as well as a statesman and his *The History of Richard III* is considered a masterpiece of English historiography, although its image of the evil tyrant Richard serves more as Tudor propaganda than as accurate history. In 1516, his most important work, *Utopia*, was published. It is an account of an imaginary republic, whose inhabitants live in perpetual peace and security, governed as they are by rulers of compassion and reason – a far cry from the England of Henry VIII.

By the time Sir Philip Sidney (1554–86) came into the world, the despotic Henry was dead, and his family stood in high favour with the new King, Edward VI. The young

Wyatt's home, Allington Castle.

More's skull supposedly rests in St Dunstan's Church in Canterbury, placed there by his daughter, Margaret, who lived close by. Installed in 1901, this window shows More flanked by St Dunstan and Archbishop Lanfranc.

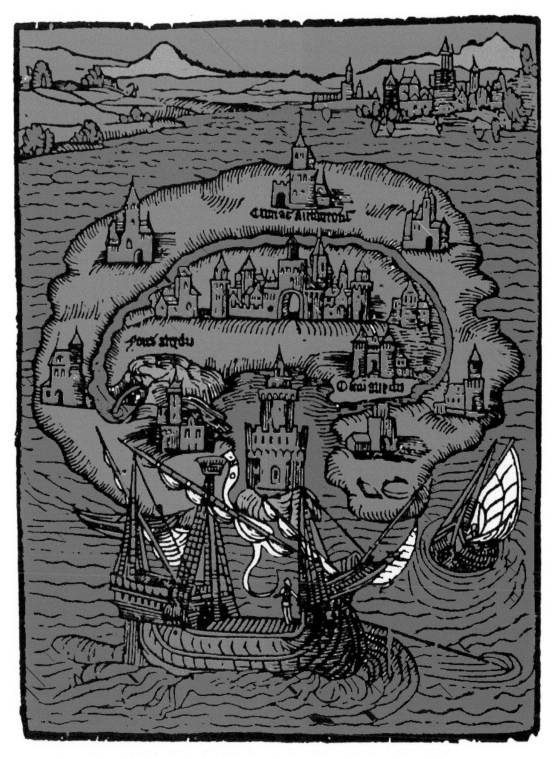

A map of the fictional Utopia.

monarch gifted Penshurst Place to his tutor, Sir William Sidney, in 1552, and here Sir William's grandson Philip was born and raised.

Sidney spent much of his early adult life travelling happily around Europe but made the mistake of upsetting Queen Elizabeth in 1579, when he wrote a letter disapproving of her possible marriage to the Duc d'Alencon. The Earl of Oxford, who approved of the match, called him 'a puppy' and demanded a duel. The Queen herself forbade it but Sidney wisely decided to keep a lower profile for a while. He returned to Penshurst, became MP for Kent and married the daughter of Francis Walsingham, the Queen's spymaster. He also began to write, with most of his work produced between 1579 and 1584.

The sequence of 108 sonnets entitled *Astrophil and Stella* sees Sidney drawing upon the work of Wyatt, thus consolidating the sonnet as a mainstay of English love poetry. It tells the story of a man's first feelings of love, the pain it causes him, and his final decision to abandon fruitless individual passion in favour of the 'great cause' of public service.

Probably written around 1579, *The Defence of Poetry* is one of the most important critical essays on poetry by any English poet and helped to elevate the form's status to that of serious literature. Sidney's premise is that poetry combines history and philosophy in language that inclines the reader towards virtue. For him, poetry should create 'a speaking picture', the purpose of which is to 'teach and delight'.

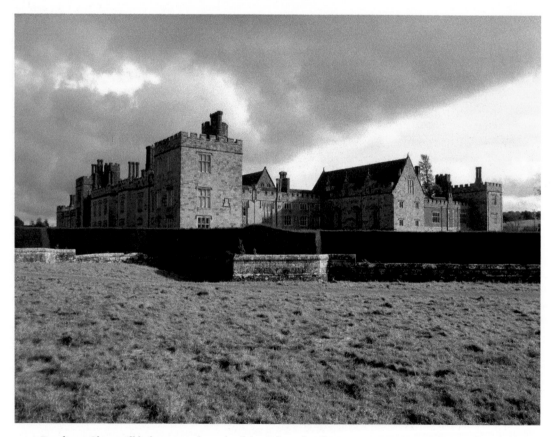

Penshurst Place still belongs to a branch of the Sidney family.

He died at the age of just thirty-one whilst fighting for the Protestant Netherlands against Catholic Spain, at the Battle of Zutphen. A thigh wound became gangrenous but even as he lay dying, Sidney lived up to his reputation as the most noble of men by giving his water to another wounded soldier, supposedly saying as he did so 'Thy necessity is yet greater than mine.' For many of his contemporaries Sidney was the epitome of what it meant to be a true gentleman. He was a skilled horseman and soldier but also a man of intellect and poetic sensibility who was devout and generous in his dealings with others. Interred in the old St Paul's Cathedral, the first commoner to be granted the honour, his status as the ultimate Renaissance Man was assured.

The manor house of Boughton Malherbe near Maidstone was home to another aristocratic author, Sir Henry Wotton (1568–1639), who, in 1599, had been sent to Europe by Elizabeth's spymasters to uncover possible plots against her. He continued his clandestine activities under her successor, James I, until he described an ambassador as

Statue of Philip Sidney in Zutphen.

'an honest man sent to lie abroad for his country'; James was unamused and never sent Wotton to lie abroad again. Eventually, he was able to claw back his reputation sufficiently to be made MP for Sandwich in 1625, his Parliamentary duties still allowing him time for writing both poetry and prose.

A close friend of Wotton's was Izaak Walton (1593–1683) whose book *The Compleat Angler* remains one of the most popular books about fishing ever written. Walton had married a descendant of Thomas Cranmer in St Mildred's Church in Canterbury in 1626 and some of his finest descriptions are of fishing in the River Stour at Fordwich for its famous trout. He also wrote several brief biographies, and his life of Wotton acts as preface to the latter's volume of poetry, *Reliquiae Wottonianae*, published posthumously in 1651.

A stretch of the River Stour, where Walton fished for trout.

4. Radicals and Revolutionaries

Richard Lovelace (1617–57) came from a long-standing Kentish family with strong military connections. He arrived at Oxford University in 1634 where one contemporary described him as 'the most amiable and beautiful person that ever eye beheld'. Unsurprisingly, he was also 'much admired and adored by the female sex'.

Above: The Lovelace family owned the manor of Bishopsbourne.

Right: Portrait of Lovelace by William Dobson, *c.* 1645. (Courtesy of Dulwich Picture Gallery)

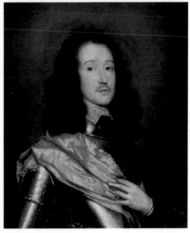

He was more than just a handsome face, however, having begun writing in his teenage years. His first collection of poems in 1638 included an elegy on the death of Charles I's daughter, Princess Catherine, and he was already known in Court circles. By 1640 he had come into possession of family estates across Kent, including at Bethersden, Canterbury, and Chart. The combination of wealth, talent and good looks should have ensured a glorious future, but this gilded life ended abruptly when the simmering conflict between King and Parliament erupted into Civil War in 1642.

As a monarchist, Lovelace presented a pro-Royalist petition to Parliament on behalf of Kent, which unfortunately annoyed the Commons so much they imprisoned him. It is at this time that he probably wrote his most famous poem 'To Althea, from Prison'. Its line 'Stone walls do not a prison make/Nor iron bars a cage' is amongst the most well-known in all English poetry. He endured another period of imprisonment in 1648 and by the time he was freed in 1649, the King was dead and like many former Royalists, Lovelace was left in very straitened circumstances. The once gilded youth died in poverty in 1657.

Nearly one hundred years after Marlowe, another dramatist was born in Kent, one who was to become an icon for many subsequent female authors – the remarkable Aphra Behn (1640–89). Her baptism is recorded in Harbledown Church although it is not known exactly where in the local area her family were living at the time.

There are several conflicting versions of her early life. For example, she claimed to have lived in Suriname on the coast of South America between 1663 and 1664 having travelled there with Bartholemew Johnson, her father, who died on the voyage, leaving her and her mother to cope alone. Another version of the story has her travelling there as the mistress of a Mr William Scot whilst working on behalf of the English secret service. There is no corroborating evidence for either story or any record to support her claim that during her time in Suriname she befriended a rebellious African slave leader. No accounts tell of any such leader but, real or not, the story forms the basis for her book *Oroonoku*, published in 1688. It tells the story of a black man's quest for freedom and is amongst the first English-printed texts to argue for the abolition of slavery. The slaves in the story are shown to be equal or even superior to their masters, a revolutionary idea at the time.

After supposedly returning to England in 1664, Aphra may have married Johan Behn, keeping his name for the rest of her life, despite the marriage being brief – if it ever took place at all. Once again, there are no evidentiary records. By 1666, the mysterious Mr Behn no longer appears to have been part of her life, thus obliging her to seek some form of employment. Contacts at court brought her to the attention of the King and she finally appears in written records working as a spy for Charles II in Bruges during the Anglo-Dutch conflict of the period. Unfortunately for Aphra, Charles did not see fit to pay her for this service and she was once again forced to hunt out work.

The playhouses which had been shut down during the joyless Commonwealth era had been reopened under Charles II and eventually she was taken on as a scribe for several theatre companies. This inspired her to write plays of her own with the first, *The Forc'd Marriage*, being staged in 1670. Encouraged by its success, she went on to write and stage nineteen plays, the most popular being *The Rover*. Charles' mistress, Nell Gwynne, appeared in the play as the prostitute, Angelica Bianca (White Angel), which must have occasioned some ribald comments from the audience.

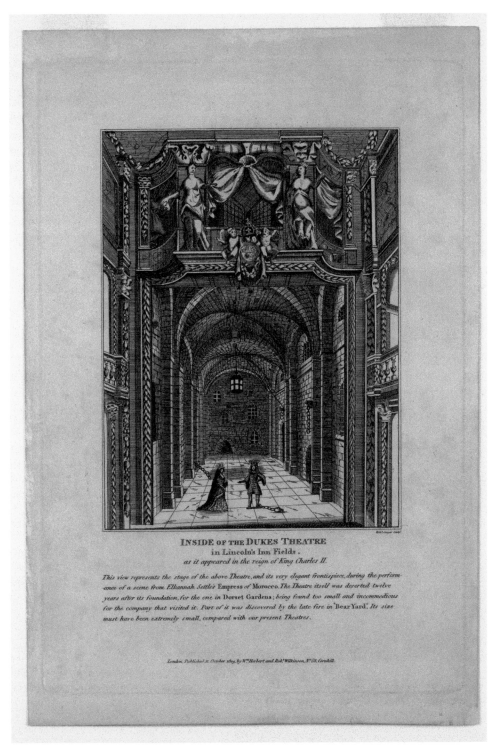

INSIDE OF THE DUKES THEATRE
in Lincoln's Inn Fields .
as it appeared in the reign of King Charles II.

*This view represents the stage of the above Theatre, and its very elegant frontispiece, during the perform-
-ance of a scene from Elkannah Settle's Empress of Morocco. The Theatre itself was deserted twelve
years after its foundation, for the one in Dorset Gardens ; being found too small and incommodious
for the company that visited it. Part of it was discovered by the late fire in 'Bear Yard'. Its size
must have been extremely small, compared with our present Theatres.*

London, Published 11 October 1809, by W.^m Herbert and Rob.^t Wilkinson, N.^o 58, Cornhill.

Interior of Duke's Theatre in London, where many of Behn's plays were performed. Charles Lamb
described Restoration comedies as 'a world of themselves almost as much as fairyland'.

In addition to prose and drama, Behn was an accomplished poet, and this was how she liked to describe herself in later years. *Poems upon Several Occasions, with a Voyage to the Island of Love* (1684) and *The Lover in Fashion* (1688) were popular anthologies of her work.

Inevitably, as a woman earning her own living, she met with the disapproval of those who regarded such behaviour as unwomanly at best and immoral at worst. As she was not afraid to point out to her many male detractors, women would gladly live independently from men, were they not deprived of education in a patriarchal society that deemed it unnecessary. It was not lack of ability or inclination that held women back but lack of means and opportunity. She said of herself that she was 'forced to write for bread and not ashamed to own it'. Behn was writing about female oppression and gender equality before such concepts even had a name. She argued against a society that saw individuals forced into unwanted marriages for the sake of wealth and status, advocating sexual freedom for both men and women.

Although buried in Westminster Abbey, Behn remained generally unknown until the twentieth century when female writers particularly began to re-evaluate her achievements. Virginia Woolf, for example, in her 1929 work *A Room of One's Own*, says all women should throw flowers on Behn's grave in honour of the woman 'who earned them the right to speak their minds'.

Anne Finch, Countess of Winchilsea (1661–1720) shared Behn's determination to be heard within a male-dominated society. An orphan at three, Anne was brought up in the home of her enlightened Uncle William, who allowed the little girl and her younger sister

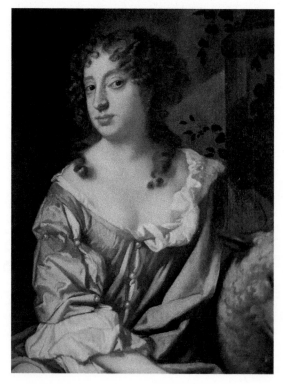

Nell Gwynne, a favourite with Restoration audiences.

to attend daily lessons alongside their brother, William. She studied classics, French, Italian, poetry, drama and history: a breadth of education most unusual for young women of the period. In 1684, she married Colonel Heneage Finch, who the following year became a courtier to King James II. When James was deposed in 1688, Finch refused to take the Oath of Allegiance to the new monarchs William and Mary, so found himself imprisoned. On his release, he and Anne moved to Eastwell Manor near Ashford, at the invitation of Finch's nephew, the Earl of Winchilsea. Here they found security, living at Eastwell for twenty-five years, until Finch became 5th Earl on the death of his childless nephew in 1712.

Anne, now a countess, carried on with the intellectual pursuits of her earlier life. She had written poetry secretly for many years and was fortunate to have a husband who encouraged her in her endeavours. In 1713 *Miscellany Poems* appeared in print, the first in a series of volumes in which Finch proved herself a versatile and sensitive poet, unafraid to explore her own emotions and personal difficulties or to use poetry to explore political and philosophical matters.

Her own background led her, like Behn, to champion women's education and despite being happily married herself, her poetry makes it clear that she fully understood the frustration and domestic isolation suffered by so many women. In 'The Unequal Fetters', she writes that women are 'close Pris'ners' in marriage whilst men can still live 'At the full length of all their chain'. In his eulogy at her funeral in 1720, her husband paid tribute to her writing when he said that to describe her required 'a masterly pen like her own'.

Finch remained a popular poet in the decades that followed, with Wordsworth writing in praise of her in an essay in 1815, although her popularity waned as the nineteenth century progressed. As with Behn, it was the twentieth-century feminist movement that led to a renewed appreciation of the work of this unusual woman.

Eastwell Manor is now a hotel and spa.

William and Mary seen on the painted ceiling of the Old Royal Naval College, Greenwich. Finch never really accepted the Hanoverian dynasty.

Close to the seafront in Deal stands the birthplace of another remarkable woman, Elizabeth Carter (1717–1806). Like Finch, she was fortunate in having a father who believed in education for women and his daughter grew up to become an outstanding linguist, proficient in at least eight languages. She resisted familial attempts to find her a husband, preferring the intellectual independence of remaining single. Her reputation was founded upon her translation of the works of Epictetus, an early Greek Stoic philosopher, which she published to much scholarly acclaim in 1758. She became a member of the Bluestocking Society, a literary discussion group which attracted many leading female intellectuals of the day, as well as being involved in the anti-slavery movement. Virginia Woolf regarded her as another feminist inspiration, urging women to 'pay homage' to her 'robust shade'.

Christopher Smart (1722–71) began life on Viscount Vane's Fairlawne estate in Shipbourne, where his father was steward. He was clearly highly respected as the Viscount bequeathed him sufficient money for the purchase of a substantial property – Hall Place in East Barming. Christopher became a pupil at Maidstone Grammar School and then moved on to Pembroke College, Cambridge, in 1739 where he gained a reputation as both an academic and a writer. His good standing was steadily eroded, however, as his lifestyle became ever wilder.

By 1750, Smart had abandoned his life as a College Fellow and academic and moved to London where he wrote for some of the many popular periodicals and broadsheets of the time, including *The Midwife*, under the pseudonym Mrs Mary Midnight. He continued

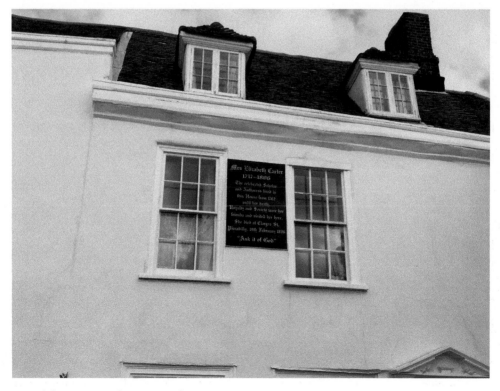

Carter's house in South Street, Deal.

to write poetry and *Poems on Several Occasions* was published in 1752, containing the lengthy poem 'The Hop Garden', which is essentially a manual in verse form on the best way to cultivate hops.

Despite marrying and fathering two daughters, he still lived a profligate lifestyle and drank excessively. He seems to have suffered from bouts of mental instability and religious mania where he would drop to his knees in the street and pray frenziedly. In 1757, he was admitted to St Luke's Hospital for Lunatics as a 'Curable Patient'. The treatment he received seems to have left something to be desired, as by the time he left he had been reclassified as 'incurable'. He later took up residence in Mr Potter's Madhouse in Bethnal Green, by which time his long-suffering wife and children had left him for a new life in Ireland. His only companion was his cat Jeoffrey, about whom he writes in his most famous poem: 'For I will consider my cat Jeoffrey/For he is the servant of the Living God, duly and daily serving him.' He believed that all living things live in a constant state of praise, a visionary approach that foreshadows ideas later espoused by William Blake.

The late 1700s were a time of great political and social unrest both in Europe and the American colonies; the writings of Thomas Paine (1737–1809) helped to spread many of the central tenets of democracy we take for granted today. He began life in Thetford, in Norfolk, where he was educated in the town's grammar school. After some time at sea, he set up a stay maker's business in Sandwich in 1759 which failed shortly after.

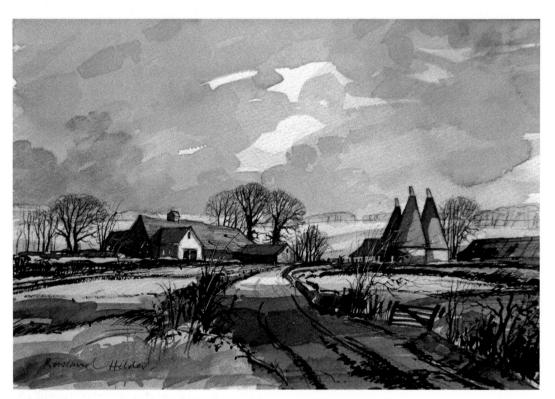

Oast houses for drying hops are a feature of the Kentish landscape. (Picture from author's own collection)

Above: Memories of Shipbourne sustained Smart throughout his life.

Right: Paine's former home can today be rented as holiday accommodation.

His career in corsetry over, he moved to Margate where he suffered the loss of his wife and baby in childbirth. A second marriage having failed, he left England for America in 1774, in search of a fresh start. Once there, he quickly became absorbed in the campaign to gain independence from Britain. In 1776, his pamphlet *Common Sense* appeared to widespread acclaim. In it he denounces the hereditary monarchies of Europe as absurd and castigates George III for his treatment of the colonies. America, he writes, has the chance to build a new system based on democracy and personal liberty, and its inhabitants have 'the power to begin the world over again'. It is Paine who first calls America 'the United States' and he is honoured there as one of the leading voices of the American Revolution.

In 1791, inspired by the French Revolution of 1789, *The Rights of Man* was published in which he expands his vision of republican societies based on principles of individual freedoms, equality and the common good. The book sold nearly one million copies and helped to enshrine the idea that governments must exist only to serve the will of the people, rather than acting as instruments of oppression.

William Hazlitt (1778–1830) was born in Mitre Lane in Maidstone, but it was not long before his restless father moved the family first to Ireland and then to America, before returning to England. William Hazlitt Sr sent his son to Hackney College where political

Statue of Paine in his birthplace, Thetford in Norfolk.

issues were hotly debated, and, like Paine before him, William Jr developed an abiding belief in the rights of man and individual liberties, writing that 'The love of liberty is the love of others; the love of power is the love of ourselves.' He extended his ideas when in 1805, he published *An Essay on the Principles of Human Action*, in which he set out to prove that 'the human mind ... is naturally interested in the welfare of others', at a time when many philosophers were arguing that selfishness was the natural human condition.

In 1798, he chanced to meet the Romantic poet Samuel Taylor Coleridge, who in turn introduced him to William Wordsworth. Under their influence, Hazlitt developed an appreciation for the instructive power of poetry which in due course led to his study *Characters of Shakespeare's Plays* in 1817. For the first time, all of Shakespeare's plays were considered in one volume of criticism and his focus on the psychological realities of the characters was groundbreaking. It established him as one of the most eminent nineteenth-century literary critics, with his work influencing Shakespearean scholars well into the twentieth century.

Such high-minded occupations did not prevent him in indulging his love for wine and women, which often led to trouble. His friendship with Coleridge and Wordsworth, for example, was badly dented when, on a visit to their Lake District homes, he propositioned a local woman. Discretion being the better part of valour, he fled under cover of darkness.

He frequently lived beyond his means, ending his days dying of stomach cancer in one room of a Soho boarding house. Despite his reduced circumstances, he was still able to say at the very end 'Well, I have had a happy life.' Hazlitt was mourned by many of the finest writers of the day, who forgave him his sins, remembering rather his charm and

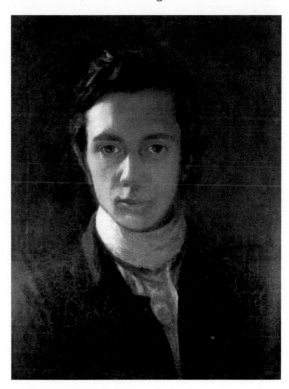

Self-portrait of Hazlitt, 1802.

great intellect; at his memorial service he was described as an 'advocate of the rights and liberties of Man, in every cause and in every clime'.

When not wandering around the Lake District, Hazlitt's friend Coleridge spent a great deal of time in Ramsgate, which he had first visited in 1819. He called it by his own name of Porta Arietina, staying at 3 Wellington Place. He was a keen sea-bather, describing a swim at Dumpton Gap as 'a glorious tumble in the waves'. Fellow poet John Keats (1795–1821) also enjoyed the delights of the Kent coast, staying in Margate in 1816 and 1817, in rooms overlooking Hawley Square. It was during his visit in 1817, whilst working on 'Endymion' that he decided to dedicate his life to poetry – a career brought to a close only four years later, when he succumbed to tuberculosis.

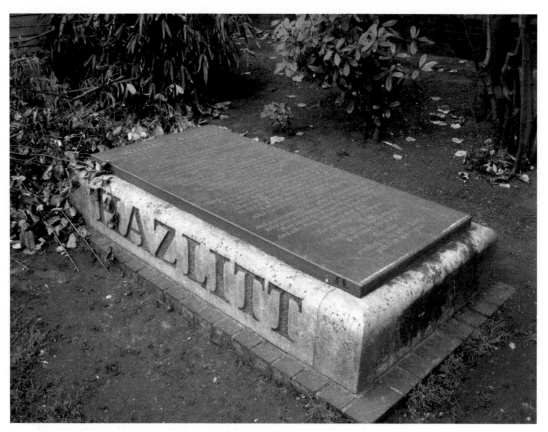

A monument to Hazlitt was unveiled in St Anne's churchyard, Soho, in 2003.

5. The Georgians and Victorians

Rosings, Pemberley, Mansfield Park, Northanger Abbey ... it is not surprising that Jane Austen (1775–1817) has had her books described as 'country house' novels, her characters are so often seen against the backdrop of a large estate where the strict codes of Regency society must always be upheld.

Although Austen lived for most of her life in the Hampshire villages of Steventon and Chawton, it is reasonable to suggest that much of her inspiration came from her many visits to Kent, where her father's family had lived for generations. Her father, George, had been born in Tonbridge, living in East Street with his Aunt Betsy after the death of his mother before he was two. His Uncle Francis, a successful Sevenoaks solicitor, paid for the boy to attend Tonbridge School and after graduating from Oxford and being ordained, George returned to the school as a master between 1754 and 1757. During this time, he was also the curate of Shipbourne before his cousin, Thomas Knight of Godmersham, offered him the living of Steventon, one of the Knight family estates. It was here that Jane was born in 1775, the seventh child of Revd Austen and his wife, Cassandra. He wrote to his half-brother William's wife at their home in Seal to announce the arrival of 'another girl, a present plaything for her sister Cassy'.

Revd Austen maintained close ties with his Kentish relations throughout his life, regularly taking his family on visits. In 1743, Uncle Francis bought The Red House in Sevenoaks High Street (still occupied by a firm of solicitors) and it is here that Jane came with her parents in 1788 at the age of twelve. Francis was agent for the Knole estate which bordered The Red House, a connection that would have granted his visitors access to the house and deer park of this magnificent Elizabethan manor. His young niece cannot fail to have been impressed.

Uncle Francis invited the Seal relations to dinner at The Red House during Jane's visit although her cousin Philadelphia seemed to have been unimpressed – when writing to her brother the next day she informed him that Jane was 'whimsical and affected'.

In the early 1780s, Jane's older brother, Edward, had been adopted by his wealthy, childless cousin Thomas Knight who was heir to a large estate in Godmersham. Now known as Edward Knight, he married Elizabeth Bridges in 1791; her father, Sir Brook Bridges, owned an estate at Goodnestone where the couple moved, setting up home in a house called Rowling. Jane's first visit to them here came in 1794. It was during such visits to Rowling that Jane began the first drafts of *Sense and Sensibility* and *Northanger Abbey*, whilst at the same time enjoying the company of a growing family of nieces and nephews. She was a frequent visitor to Elizabeth's parents at Goodnestone House, invited to the sort of dances and evening entertainments that appear regularly in the novels.

Edward inherited Godmersham in 1797 and it became central to the lives of his siblings in the years that followed. For Jane, who made many lengthy visits there between 1798 and

In September 1805, Austen stayed at the Dower House in Goodnestone and wrote of the pleasure she took in strolling around the estate's grounds.

1813, the roads in and out of Kent would have become familiar to her. One popular route would have seen her passing through Westerham where the George and Dragon and the King's Arms would have been welcome stops. What is now the A2 was also a well-travelled road and her letters tell us that on occasion she stayed in both Dartford and Sittingbourne.

Once at Godmersham, her life seems to have been a busy round of visiting and being visited in return. The men would take part in the usual country pursuits of hunting, shooting and fishing, whilst the ladies entertained the children, read, sewed, painted and practised their music. Her time there also provided ample opportunity to note the inner workings of a country estate and to observe the lives of those connected to it. It has been suggested that Godmersham was the inspiration for *Mansfield Park* and Jane clearly found its surroundings appealing, writing in 1808 that 'The country is very beautiful. I saw as much as ever to admire in my yesterday's journey.'

Jane was a regular visitor to Canterbury, drawn by its shops, theatres and the winter balls held at Delmar's Assembly Rooms above the Canterbury Bank at 49 High Street, still a bank today. On 3 November 1813, she went with Edward, now a magistrate, to the newly completed prison in Longport where she wrote in a letter that she 'went through all the feelings which people must go through ... in visiting such a Building'. She seems to have recovered her composure swiftly as the rest of the day was spent in shopping and the purchasing of a concert ticket.

Trips to the seaside were popular and Deal appears often in her letters, especially whilst her naval brother, Frank, was living there with his wife and children. It is in Deal

Austen's niece, Marianne Knight, recalled how Aunt Jane would read aloud extracts 'of whatever novel she was writing' on her visits to Godmersham House.

Both Jane and her sister, Cassandra, attended social gatherings at Chilham, home of their friends the Wildmans. In 2009, the village square was transformed into eighteenth-century Highbury for a BBC production.

that Admiral Croft's indomitable wife Sophy falls ill in *Persuasion*, whilst her husband is on North Sea patrol. Unlike Coleridge, Ramsgate seems not to have been to her taste, for it is here that the young Georgiana Darcy is taken in *Pride and Prejudice* as part of Mr Wickham's plan for their elopement. In *Mansfield Park*, the town is once again censured when the Sneyd women of Albion Place are considered far too free and easy with men outside of their acquaintance.

Whilst spending pleasurable times in Kent, it was doubtless clear to Jane that for many of her brother Edwards's circle, she was the 'poor relation', increasingly to be pitied as she grew older and remained unmarried. One wonders how often she had to endure the company of those who thought themselves her superior simply because of their money and rank; the casual cruelty shown by Emma in that novel towards Miss Bates gives a hint of what she may have experienced. Despite this, on returning to Hampshire in December 1798, she wrote to Cassandra that 'Kent is the only place for happiness'.

Usually known by his pseudonym of Thomas Ingoldsby, the clergyman Richard Harris Barham (1788–1845) used his Kentish background to good effect. His father was a well-respected hop farmer who also served as Mayor of Canterbury.

An accident when he was fourteen shattered his arm, leaving him with a permanent disability. This did not prevent him from graduating from Oxford in due course and deciding upon a career in the Church. He was a curate in several small Kentish parishes, including Snargate where he began work in 1817. From the 1820s, he began to contribute articles to popular publications of the time, including *Blackwoods Magazine*, but it was *The Ingoldsby Legends* that were his greatest success. Published in editions of *Bentley's Miscellany*, the stories drew heavily upon his extensive knowledge of Kentish myths and legends, as well as upon local tales told him by his mother when he was a boy. They were hugely popular; an edition of the collected stories published in 1881 sold over 60,000 copies on the first day. In the tale *The Leech of Folkestone*, Barham claims that 'The World ... is divided into Europe, Asia, Africa, America, and Romney Marsh.'

Amongst the greatest of all English novelists, Charles Dickens (1812–70) lived for much of his life in Kent having first moved there as a small child. Alfred Jingle says in Dickens's *The Pickwick Papers* 'everyone knows Kent. Apples, cherries, hops, and women!' and the county features throughout his work.

His father, John, was a clerk in the Naval Pay Office in Portsmouth when Charles was born in 1812. By 1815, he had been transferred from Hampshire to Kent, a brief spell in Sheerness being followed by a longer-term placement at the Royal Naval Dockyard in Chatham, where they lived at 2 Ordnance Terrace. Dickens calls it Gordon Place in his short story 'Old Lady'. Here the boy attended school and enjoyed a normal family life. In 1822, however, his father was sent to work in London where he got into substantial debt, eventually being consigned to Marshalsea Debtors' Prison. His ten-year-old son's life was shattered.

Forced to leave school, he ended up working ten-hour days for 6 shillings a week in a blacking factory near to present-day Charing Cross station. His life in Chatham must have

This pub stands near the site of Ingoldsby's birthplace, destroyed by enemy bombing in 1942.

The Jackdaw of Rheims tells how a bird steals a cardinal's ring and is made a saint. The Jackdaw pub in Denton is named in its honour.

seemed idyllic by comparison; when David Copperfield walks from London to Dover to find his great-aunt Betsy Trotwood, he sees Chatham as 'a mere dream of chalk ... mastless ships in a muddy river, roofed like Noah's arks'.

An inheritance from his grandmother eventually allowed him to return to school, after which he became a journalist before trying his hand at fiction. In 1836, *The Pickwick Papers* was published, its success providing the financial security necessary for him to marry his fiancée, Catherine Hogarth. The couple honeymooned in Chalk, near Rochester, although this would prove to be a briefly tranquil period in what was to become an extremely unhappy marriage. The steady arrival of nine children meant the family moved to larger accommodation at regular intervals until at last, in 1855, Dickens purchased Gads Hill, near Rochester.

The house had held a special place in his imagination for many years before he acquired it; in *All the Year Round* published in 1860, he tells the story of a 'queer small boy' who is frequently told by his father that if he works hard enough, he may one day live there. Dickens did not share his new home with his wife, however, as by the time he moved in in 1857, the two were estranged and she never joined him. Dickens kept the house as his principal residence for the remainder of his life, frequently inviting guests who

The Pickwick Papers sees Chatham appear as Mudfog, smelling of 'pitch, tar, coals and rope yarn'. Today, the former Naval Dockyard is a museum.

Gads Hill becomes Scrooge's childhood home in *A Christmas Carol*, with a 'cupola on the roof, and a bell hanging on it'.

would be collected at Higham station with Dickens himself driving the pony-cart. One such visitor was Hans Christian Anderson, a fractious guest to whom his hosts waved a relieved farewell at the end of an awkward five weeks.

In 1850, *David Copperfield* was published, a semi-autobiographical novel with Kent playing an important role in the life of the eponymous hero. Having fled the cruelty of his stepfather, David takes refuge with his Aunt Betsy in Dover and she decides that he should attend school in Canterbury, at what must surely be King's, described as a 'grave building in a courtyard, with a learned air about it'. Mr Micawber stays at the Sun Hotel and Uriah Heep oils his way around the city from his home in North Lane. David's time in Canterbury is a happy one and before he leaves, he wanders through 'its dear and tranquil streets'. Dickens himself never lived in the city but knew it well and in 1869, he took a group of American visitors on a tour of the city where he impressed them with his detailed knowledge.

Broadstairs was also well known to him; he first visited in 1837 and then for a few months every year for the next ten. He completed *Nicholas Nickleby* there in 1839 and was working on *The Old Curiosity Shop* and *Barnaby Rudge* during his stay in 1840. In 1850 and 1851, he rented a house overlooking the harbour, called Fort House. Having once been called Bleak House, it reverted to that name after Dickens's novel appeared. Despite what many understandably think, none of the book was written there , although a house

Dickens at Gads Hill. (Author unknown)

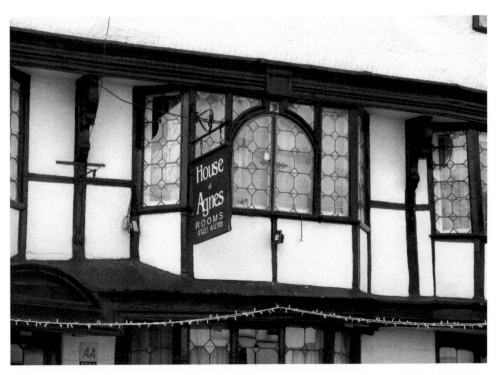

Agnes Wickfield lived in 'a very old house bulging out' over St Dunstan's Road, now known as The House of Agnes.

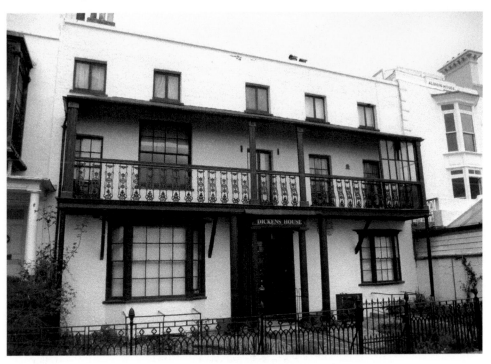

Mary Strong's former home is now the Dickens House Museum in Broadstairs.

in Nuckle's Place in the town does appear in *David Copperfield*. This is the home of a somewhat eccentric lady of Dickens's acquaintance, Mary Pearson Strong; a 'very neat little cottage with cheerful bow windows', it is the model for Aunt Betsy Trotwood's home, albeit transported to Dover.

The first novel Dickens wrote after moving into Gads Hill was *Great Expectations* in which the Medway of his youth features significantly, especially the marshes of the Hoo Peninsula, that 'dark flat wilderness ... intersected with dykes and mounds'. Distinctive graves in the churchyard at Cooling belong to thirteen children of the Comport family and match closely the description of the graves of Pip's parents and five brothers. The church itself is probably Higham as it is separated 'a mile or more' from the village and has a gate leading directly to the marshes as Dickens describes.

The convict Magwitch escapes from one of the prison hulks that were moored along the shores of the Medway at the start of the nineteenth century, where prisoners lived in appalling conditions whilst awaiting transportation to the colonies. Men are recorded as having attempted escape across the mud of the estuary at high tide and the remains of those who were unsuccessful have been discovered over the years. There is no doubt that Dickens would have seen these hulks and been aware of those who tried to break for freedom. A reconstruction of part of a hulk is on display in Rochester's Guildhall Museum.

Away from the marshes, the city of Rochester is the home of the Pumblechooks and Satis House, where Miss Havisham crumbles away, is based on an actual building there,

In Cooling churchyard are the tombs of thirteen children of the Comport family, the inspiration for the 'lozenge-shaped graves' of Pip's parents and five brothers in *Great Expectations*.

Restoration House. The city had featured in his work before *Great Expectations*, appearing as itself in *Pickwick Papers* and as Great Winglebury in *Sketches by Boz*. It is also the setting for his last and unfinished novel, *The Mystery of Edwin Drood*, where it becomes Cloisterham. Amongst the last words he wrote on the day before his death in June 1870 were these about the cathedral: 'The cold stone tombs of centuries ago grow warm, and flecks of brightness dart into the sternest marble corners.'

The summer Dickens Festival and the Dickensian Christmas events now draw people to Rochester, where visitors are encouraged to stroll through the streets, preferably dressed as one of his memorable characters.

For many Victorian readers, William Makepeace Thackeray (1811–63) was second only to Dickens in popularity. He had spent many years as a freelance journalist before the huge success of *Vanity Fair* (1848) made him a household name. Set during the Napoleonic Wars, it charts the path of the penniless but ruthlessly ambitious heroine, Becky Sharp, one of the most memorable of all literary heroines. Thackeray had spent boyhood summer holidays in Tunbridge Wells and in 1860 he came to live there in Rock Villas, writing 'can the world show a land fairer, richer and more cheerful'.

A close friend of Dickens, Wilkie Collins (1824–89) began his working life as a tea merchant. His office was on London's Strand, which was fortunate for him as he had

Moved to Rochester from Gads Hill in 1960, the Swiss Chalet was one of Dickens' favourite places in which to write.

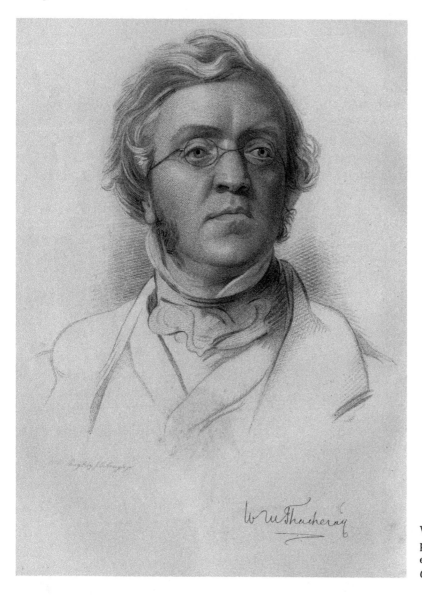

William Thackeray pictured in an engraving from *The Cornhill Magazine.*

no interest in selling tea but plenty of interest in the many theatregoers, writers and journalists who worked in the area. He was lucky enough to be introduced to Dickens in 1851 and their rapid friendship allowed him to leave his hated office for good. He visited Gads Hill often and began to work with Dickens on *Household Words* and *All the Year Round.* He moved on to writing novels, publishing *The Woman in White* (1860) and *No Name* (1862). The latter is an extraordinary book for its time, telling the story of an illegitimate woman fighting for independence in the patriarchal world of mid-Victorian society.

It was not only Kent's writers of fiction who were challenging Victorian mores. In 1859, Charles Darwin (1809–83) published *On the Origin of Species,* in which he advanced the theory that the natural world was not born out of a single act of creation but had evolved

Thackeray was a notorious glutton, so would doubtless be pleased that his old home is now a restaurant.

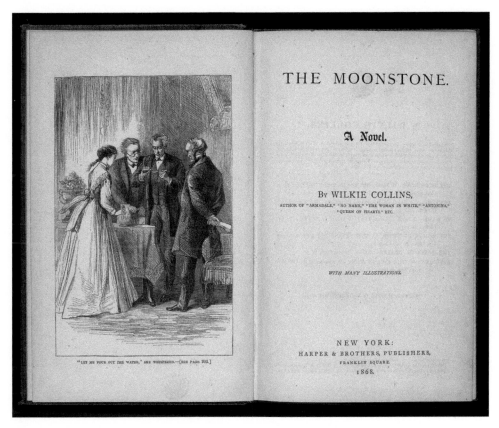

The Moonstone (1868) is considered the first true English detective novel. Pictured is a page from the first edition. (British Library Collection)

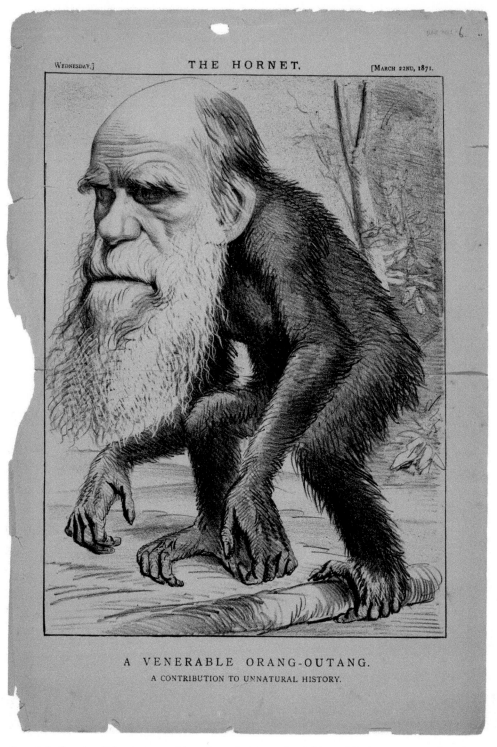

Darwin's theories did not meet with universal approval, as this satirical response makes clear. (Unknown author – UCL Digital Collection 18886)

over millennia in a process he called natural selection. Nowadays, when this theory is so well accepted it is hard to imagine the controversy and anger Darwin's book caused, seeming as it did to relegate God to a somewhat passive by-stander, if indeed He existed at all.

Darwin had begun to formulate his revolutionary ideas about evolutionary biology whilst serving as a naturalist aboard HMS *Beagle*, as it carried out extensive surveys of South America and its waters, between 1831 and 1836. By 1841, he was back on dry land, married and living in the small Kent village of Downe, his home for the rest of his life.

Away from the world of science, Walter Pater (1839–94) was one of the nineteenth century's most important commentators on art and literature. His family had moved to Summer Hill in Harbledown in 1853 so that he could attend King's School, Canterbury. Seeing it daily, the cathedral's beauty, where 'the melodious mellow-lighted space [is] always three days behind the temperature outside', affected him deeply. Even when he was teaching Classics and Philosophy at Oxford his passion for the visual arts remained, culminating in the publication of *The Renaissance* in 1873. It proved controversial, with many academics at the time feeling that Pater was turning his back on institutional religion and traditional morality. Instead, the book argues that

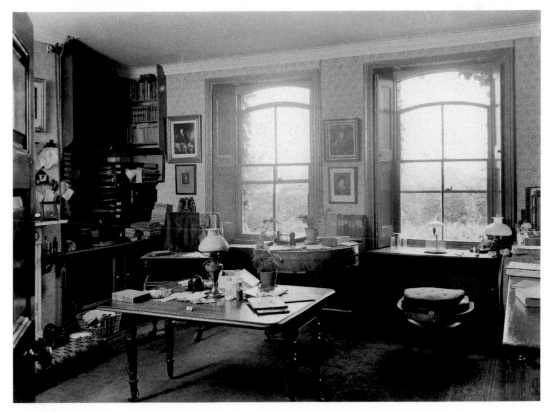

Visitors to Down House can see Darwin's study recreated using many of his belongings. (Wellcome Collection CC BY 40)

beauty is all; life should be about immersing oneself in sensory experiences, and that to 'burn always with this hard gemlike flame, to maintain this ecstasy, is success in life'. In this, and subsequent works, Pater proposes that art does not require any political, philosophical, or moral purpose. For Pater, art should be 'self-sufficient', existing only for itself. This principle of 'Art for art's sake' was not a new one but in Pater it found a powerful and persuasive advocate, placing him firmly at the heart of the Aesthetic Movement of the 1870s and 1880s.

The Pre-Raphaelites movement was central to the development of Victorian art and one of its founders was Dante Gabriel Rossetti (1828–82). He lived for most of his life in London, together with his sister Christina, where he not only painted but also wrote poetry. However, in February 1882, he moved to Birchington-on-Sea, hoping the sea air would be beneficial to his failing health. It was in vain, as he died in that same April and was buried in the graveyard of All Saints Church.

A view of Canterbury Cathedral from King's School.

Rossetti's headstone was designed by Ford Madox Ford. The church contains a window in his memory commissioned by his sister, Christina.

6. Into the Twentieth Century

If Darwin changed the face of science fact, one of the most influential of all science fiction writers was born in Bromley, not far from Down House. Herbert George Wells (1866–1946) was an intelligent boy whose own miserable experiences working in a draper's shop fuelled his ambition to step outside of the social class in which he had been raised. In 1884, years of study paid off when he gained a scholarship to Imperial College London, where his favourite tutor was Thomas Huxley, a friend and collaborator of Darwin. On graduating, he began life as a teacher; to supplement his income he submitted light-hearted articles to journals such as *The Pall Mall Gazette* before producing longer and more serious pieces.

In 1895, he published the novella that established him as a writer, *The Time Machine*, a phrase he coined himself. The main character builds a machine in which he travels to AD 802,701 where he encounters the conflicting worlds of the Eloi and the Morlocks. The story is not only a frightening vision of the future but also acts as a vehicle for Wells' strong socialist convictions (in 1921, he travelled to Russia where he met both Lenin and Trotsky).

Following the success of *War of the Worlds* (1898) and *The Invisible Man* (1897) he moved to Sandgate near Folkestone with his second wife in 1898, setting up home at Beach Cottage, before moving to Spade House three years later. Wells produced a great deal of work during his time in Sandgate, including *The First Men in the Moon* (1901), wherein the protagonists somehow manage to launch themselves into space from a bungalow in Lympne. The astronauts meet with fierce resistance from the moon's inhabitants and only a single survivor returns to a landing site in Littlestone.

Wells was not only a prolific writer but also an inveterate womaniser, and life in Sandgate ended in 1909, when his wife finally lost patience with his many affairs with local women, insisting they move to London. It made little difference as before too long Wells began an affair with Rebecca West, twenty-six years his junior, who went on to become a highly regarded author and journalist herself.

Although works such as *The History of Mr Polly* (1910) and *Kipps* (1905) show Wells tackling his concerns about social and economic inequalities, he remains most famous for his innovative and prophetic science fiction stories. Wells was remarkable in his predictions, foreseeing the invention of air and space travel as well as television. In 1913, in *The World Set Free*, years before its invention, he wrote of the dreadful power of an 'atomic bomb'. Wells' work is central to the development of science fiction as a genre, and it seems appropriate that a crater on Mars is named in his honour.

Joseph Conrad (1857–1924) was born far from Kent, in an area of Poland that was alternately under Polish and Ukrainian control. Named Jozef Teodor Konrad Korzeniowski, he was an intellectually precocious boy, who nonetheless hated school,

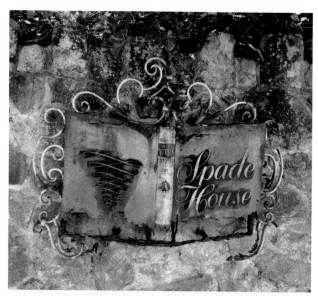

Wells lived for nearly a decade in
Spade House, Sandgate.

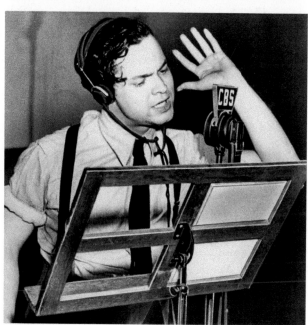

War of the Worlds (1897) was turned
into a radio play by Orson Welles in
1938 – many listeners believed the
Martians had really landed.

leaving it to go to sea at the age of sixteen. After a twenty-year career, his last voyage
was from Adelaide to London where he docked in 1893; a fellow passenger was John
Galsworthy, future author of *The Forsyte Saga*, and the two stayed in touch long after the
journey ended. Conrad had become a British national in 1889, and now decided the time
was right to remain in England and pursue long-held literary ambitions. His first novel,
Almayer's Folly, appeared in 1895.

In 1896, he married the much younger Jessie George, which caused consternation
amongst his snobbier friends as she was a working-class woman with little of the social

polish they felt necessary for a man with roots in the Polish nobility. Despite such disapproval, the marriage seems to have worked, with Jessie providing him with the domestic security necessary for his writing.

Many of his novels draw inspiration from his earlier travels. *Heart of Darkness* (1899), for example, is an account of life in the Belgian Congo where Conrad once worked. The novella aims to show that precious little divides the supposed civilised white man and the 'savages' he regards as inferior. *Nostromo: A Tale of the Seaboard* (1904) is set in the violent fictitious South American republic of 'Costaguana'. *The Secret Agent* (1907) takes the reader to London where a sinister spy, Verloc, plots to bomb the Greenwich Observatory; it is dedicated to H. G. Wells, who had been an early admirer of his work. Literary critics regard Conrad as one of the finest of all prose writers in English; an extraordinary accolade for an author who did not even speak the language until he was in his twenties.

After living in a series of rented houses, the Conrads settled into Oswalds in Bishopsbourne.

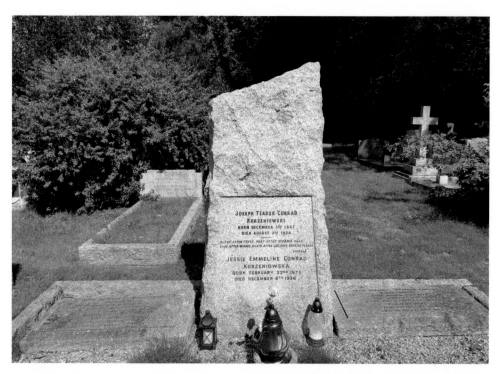

Conrad is buried in Canterbury Cemetery with lines from Spenser's *The Faerie Queen* engraved on his tombstone.

In 1898, Conrad had been introduced to fellow author Ford Madox Ford (1873–1939). Ford had been living in Kent since 1894, when he and his wife moved to Bonnington on the Romney Marsh before moving on to Pent Farm in Postling. Ford later rented Pent Farm to Conrad, who wrote *Heart of Darkness* there. The two collaborated on three novels together, including *Romance* (1903), but they were not received with much critical enthusiasm. In 1924, however, Ford published a memoir of his friendship with Conrad and the section devoted to the writing techniques the two men formulated is seen by many as a vital tool for anyone wishing to write fiction.

Ford wrote about eighty novels, some of which are amongst the finest examples of early twentieth-century English prose. *The Good Soldier* (1915) is considered a masterclass in Modernist techniques with its complex plot, shifting time frames and use of an unreliable narrator. The four novels collectively known as *Parade's End* (1924–28) are based upon his experiences as a soldier in the First World War and are regarded as amongst the best of all literature about the conflict.

Not content with writing his own books, Ford was instrumental in promoting the work of many of the writers of the day through the two periodicals he founded. *The English Literary Review* and *The Transatlantic Review* contained the work of Conrad, Wells, Thomas Hardy, Henry James, and D. H. Lawrence amongst others, making him one of the key figures in the development of modern British and American literature.

M. R. James (1862–1936) is referred to, for good reason, as the master of the English ghost story. Montague Rhodes James began life in Goodnestone, the village where Jane

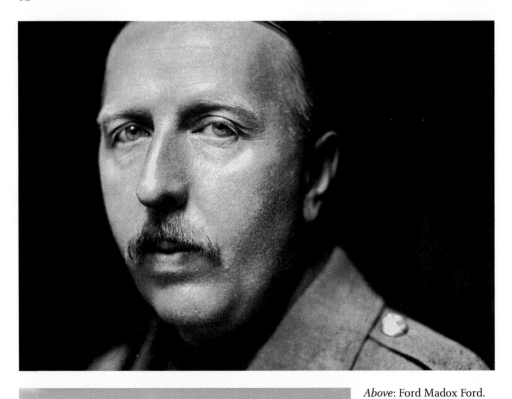

Above: Ford Madox Ford.

Left: Goodnestone's Holy Cross Church, where James' father was curate.

Austen had been so happy. A scholarly boy who went on to become a Cambridge don, his works on religion and the Middle Ages are still admired by academics. He began writing ghost stories as Christmas Eve entertainments to be read aloud to friends in his rooms in King's College. In time, these stories were published in volumes such as *Ghost Stories of an Antiquary* (1904), *A Thin Ghost and Others* (1919) and *A Warning to the Curious* (1925).

In these books he established many of the now familiar attributes of a ghost story, where supernatural events occur to ordinary people in realistic settings. James said that the ghost must be 'malevolent or odious' to act as a frightening contrast to the ordinary world in which it has manifested itself. His hope was that his stories should leave readers 'pleasantly uncomfortable when walking along a solitary road at nightfall'.

Becoming the Poet Laureate should usually ensure a writer a measure of fame but not so for Alfred Austin (1835–1913) and Robert Bridges (1833–1930). Austin was little admired by his poetic contemporaries, and it was rumoured by some that he only got the job as Poet Laureate in 1896 because nobody better was interested. Lines such as 'The Spring-time, O the Spring-time!/Who does not know it well?/When the little birds begin to build,/And the buds begin to swell', suggest they may have had a point.

Bridges spent the first ten years of his life in Walmer, one of a family that could trace its Kentish roots back to a sixteenth-century rector of Harbledown. He trained as a doctor, only taking up poetry when his own health let him down. He took over from Austin as Poet Laureate in 1913 but remained little known despite this. It was not until *Testament of Beauty* (1929) that he gained some renown. He is best known today not so much for his

In *Oh Whistle and I'll Come to You* an arrogant Cambridge don finds an old whistle whilst on a winter seaside holiday. He blows it, unleashing a terrifying phantom. (flickr.com)

Alfred Austin.

own poetry, but for ensuring that the poems of his friend Gerard Manley Hopkins were finally published, albeit posthumously, in 1918.

E. M. Forster (1879–1970) was brought up by his widowed mother, supported by several indulgent aunts, one of whom bequeathed her nephew the sum of almost £1 million in today's money. This enabled his mother to move from London and secure Edward a place as a day boy at Tonbridge School. A typical Victorian public school, Tonbridge placed great emphasis upon sports and traditional masculine pursuits and the young Forster hated it. The delicate boy struggled to cope with the daily rough and tumble of a male-only environment and in later life, he recollected how the other boys had teased him over his lack of 'manliness'. He responded by casting himself as a lofty intellectual, which one imagines must have made things even worse.

His novel *The Longest Journey* (1907) has him rename Tonbridge and its school as Sawston and they are described in distinctly unflattering tones. Like Forster, its protagonist, Rickie Elliot, becomes a Cambridge undergraduate and tells others there of how he was bullied at the school for his physical frailty. Between 1913 and 1914, he penned *Maurice*, a not dissimilar story of a young man's life from school to university and beyond, its central difference being the obvious homosexuality of its two central characters. Forster, himself a homosexual, did not press for its publication at the time, as homosexuality was then illegal. It did not appear in print until 1971, the year after his death. It is by no means the best of his work, but it sheds light on what it meant to be homosexual in an England that had 'always been disinclined to accept human nature'.

Whilst at Cambridge, Forster became friends with Lytton Strachey and John Maynard Keynes, who went on to form the intellectual set now known as the Bloomsbury Group. It is thought likely that the high-minded Schlegel sisters in *Howard's End* are modelled on sisters Vanessa Bell and Virginia Woolf, who were part of the circle. Novels such as *A Passage to India*, *A Room with a View* and *Where Angels Fear to Tread* earned Forster

Tonbridge School.

renown whilst alive and film versions made after his death have introduced his work to a wider audience.

Another member of the Bloomsbury set was the aristocratic Vita Sackville-West (1892–1962). Born at the family seat of Knole House in Sevenoaks, she had begun to write from an early age, one of her first published works being *Knole and the Sackvilles* (1922).

Vita (left) and Virginia.

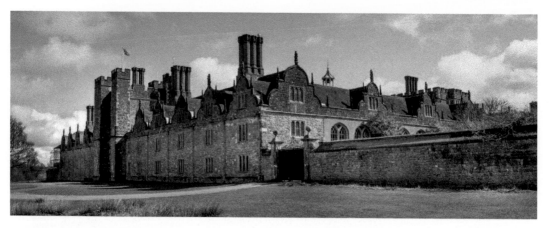

The Edwardians (1930) is set in a country house named Chevron which bears a striking resemblance to Knole House.

In 1913, she married Harold Nicolson in Knole's private chapel. Nicolson was a diplomat and after a short posting abroad, the couple moved into Long Barn in Sevenoaks Weald in 1915; reputed to have been William Caxton's birthplace, it was in a poor state of repair. Eventually the architect Sir Edwin Lutyens was employed to restore it and Long Barn became a regular meeting place for the Bloomsbury club.

Both Harold and Vita had same-sex affairs throughout their marriage and a frequent visitor to Long Barn was Virginia Woolf with whom Vita had a ten-year relationship. Woolf draws upon their affair in her novel *Orlando*; as a woman, Vita was unable to inherit her beloved Knole, the unfairness of which served as inspiration for Woolf's story of a poet who lives for centuries, changing from a man to a woman along the way. The book's original manuscript is kept at Knole, inscribed to 'Vita from Virginia'.

In 1930, the family moved to Sissinghurst Castle, once owned by the Sackville-Wests but then verging on the derelict. In *Family History* (1932), Vita describes a courtyard and ruined walls with an 'arrowy tower' dominating the scene. The couple had spent much time in the gardens of Long Barn and brought what they had learnt to the grounds of their new home. Self-taught, Vita was an innovative and exciting garden designer and Sissinghurst allowed full scope for her influential ideas. She continued to write and in 1933 she was awarded the Hawthornden Prize for Poetry for her *Collected Poems*, having already won it in 1927 for her long narrative work *The Land*, which celebrates the history and landscape of the Kentish Weald.

William Somerset Maugham (1874–1965) once complained upon reading Forster's 1927 influential critical study *Aspects of the Novel* that according to its author, the only way to write novels was to write books like Forster's own. The two men, in fact, came from not dissimilar backgrounds. Orphaned by the age of ten, Maugham was sent from his home in Paris to live with his uncle, the vicar of All Saints' Church in Whitstable.

William attended King's in Canterbury from 1885 to 1889 but, like Forster, his school days were not happy. His academic record was excellent which did not endear him to the other boys, who ridiculed his poor sporting performances and mocked his French accent. This led him to develop a stutter which led to more mockery and isolation.

From 1947 to 1961, Sackville-West wrote a gardening column for *The Observer*, drawing upon her work at Sissinghurst, including the Rose Garden, pictured here in spring.

In *Of Human Bondage* (1915), Philip Carey, who lives in Blackstable, is sent to King's School in Tercanbury, where he is lonely and miserable. It is not hard to see where that idea originated. In later years, however, he forged a happier relationship with his old school, becoming a governor and donating a library.

The Norman Staircase at King's School. Maugham's ashes are buried close by.

Works such as *The Moon and Sixpence* (1919) and *Cakes and Ale* (1930) brought him great popular success, and he became the highest-paid author of the 1930s. Contemporary critics did not regard him highly, despite this, describing his style as too plain and cliched. Maugham seems to have agreed to some extent, describing himself as 'in the very first row of the second raters'.

Called Siegfried because of his mother's devotion to Wagner's operas, the young Sassoon (1886–1967) grew up not in Germany, but in the village of Matfield, near Tunbridge Wells. His parents' marriage was not a success, perhaps because his father's Jewish family had disowned him for marrying a Catholic and the couple had separated by the time the boy was four, with his father dying only some six years later.

Siegfried attended the New Beacon School in Sevenoaks, before heading off to Marlborough College and then Clare College, Cambridge. He left without finishing his degree in 1907 perhaps in the hope of pursuing a career as a cricketer, his great ambition being to play for Kent. Although never good enough to gain a place in the county side, he often played with a local team at the Nevil Ground in Tunbridge Wells, where Arthur Conan Doyle, who lived in Crowborough, was also a regular. When not playing cricket, Sassoon seems to have spent much of his time riding and hunting, a period of his life he considers in his 1928 novel *Memoirs of a Fox-Hunting Man;* its central character, George Sherston, is a thinly veiled portrait of Sassoon himself.

The large green at Matfield is not much changed from when Sassoon lived in the village.

These rather aimless years came to an end on 4 August 1914, when Britain declared war on Germany. Sassoon enlisted with the Sussex Yeomanry on the same day. He broke his arm not long afterwards, so did not arrive in France until November 1915, by which time he had been commissioned into the Royal Welch Fusiliers as a second lieutenant. Sassoon proved to be an extremely able and courageous officer, acquiring the nickname 'Mad Jack' for his various exploits. One noteworthy incident saw him clear a trench of Germans and then sit in it reading a book of poetry. In 1916 he was awarded the Military Cross for bringing in wounded men whilst under fire.

In between all of this, he still found time to write the poetry for which he is now best remembered. He had tried his hand at verse before the war but those early Romantic poems about beauty and nature were replaced by realistic accounts of the daily horrors encountered by soldiers in the trenches. In 'Dreamers', for example, he writes of soldiers 'in foul dug-outs, gnawed by rats' as they dream of 'firelit homes, clean beds, and wives'.

He was angered by what he saw as the ineptitude of political and military leaders of the day, and he took up journalism after the war, becoming editor of the *Daily Herald*. He employed the poet Charlotte Mew as a reviewer together with E. M. Forster, who became a close friend.

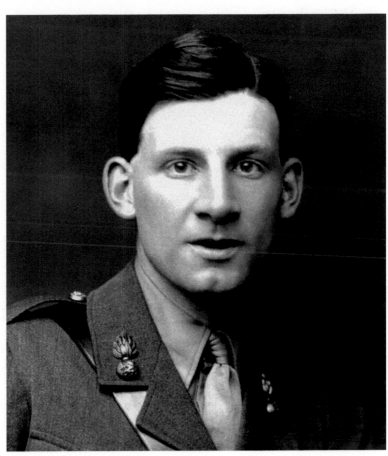

Sassoon in uniform.

Edmund Blunden (1896–1974) first came to Kent in 1900, when his parents moved from London to Yalding, after his parents became joint headteachers of the now defunct Cleaves Grammar School. He attended both Cleaves and Christ's Hospital schools before his plans to take up a place at Oxford University were pushed aside by the outbreak of war in 1914. He fought on the Somme and at Passchendaele, gaining the Military Cross in 1917 in recognition of his 'conspicuous gallantry in action'. The horrors he witnessed are vividly recounted in his 1928 memoir *Undertones of War*, which ranks alongside Sassoon's *Memoirs of An Infantry Officer* (1930) in its powerful evocation of conflict.

After the war, he took up his place at Queen's College, Oxford but found it hard to adapt to university life, abandoning his degree in 1920. In that same year, encouraged by his

The war memorial in Yalding, with Cleaves visible behind.

Cleaves Grammar School is now a private residence.

friend Sassoon, he published a collection of poetry entitled *The Waggoner* and his next book, *The Shepherd*, earned him the prestigious Hawthornden Prize for literature.

He spent most of his career teaching in universities both in Britain and the Far East before finally retiring to Suffolk, where he died in 1974. Although he lived much of his adult life far away from Kent, he readily acknowledged its influence on his work. Through his poems, with their frequent emphasis on the natural world, he sought to promote an awareness of rural England and its traditions in an increasingly urbanised society. 'I sing of the rivers and hamlets and woodlands of Sussex and Kent', he once wrote. Those childhood years in Yalding were the foundation of his poetry.

Blunden was not only a fine poet himself, but also an influential critic. He helped establish the reputations of Sassoon, Wilfred Owen and Ivor Gurney, whose poems on the stark realities of the First World War have done so much to shape our collective response to that conflict. In 1920, his study of the largely forgotten nineteenth-century poet John Clare was instrumental in establishing Clare as one of the foremost of all English nature poets.

Hours spent wandering Wandsworth Common near his childhood home fostered a lifelong passion for nature in the poet Edward Thomas (1878–1917) which is reflected in much of his work. His father was not supportive of his son's literary ambitions but

in 1894, he met the literary critic James Ashcroft Noble, who encouraged the boy and oversaw the publication of his first book, *The Woodland Life*.

Thomas formed a deep relationship with Noble's daughter, Helen, who became pregnant whilst Thomas was an undergraduate at Lincoln College, Oxford. They married in 1899 and Thomas remained determined to earn his living as a writer. He began to earn a name for himself as a reviewer and critic, often reviewing as many as fifteen books a week, as well as taking on commissions for his own original writing. He frequently suffered with bouts of angry depression as he struggled to earn enough money to keep the family whilst keeping up with his self-imposed workload.

After a few years of this, the couple's desire to live in the countryside saw them move from London to Bearsted, near Maidstone. To begin with they rented Rose Acre Cottage on the outskirts of the village, where Thomas completed his book *Rose Acre Papers*. A later move to Ivy House on the green allowed them to become more involved in village life and to form friendships with the locals, although probably not with their near neighbour, Baroness Orczy.

Born in Hungary in 1865, Orczy was the author of the *Scarlet Pimpernel* series of novels, in which the dashing Sir Percy Blakeney spends much time rescuing French aristocrats about to lose their heads during the French Revolution. She purchased Snowfields in Yeoman's Lane in 1903 and apparently enjoyed driving around the village in a horse-drawn carriage. By 1910, she had accrued enough from her writing to leave Kent for a villa in Monte Carlo.

In 1905 the Thomas family had moved again, this time to Elses Farm, near the village of Sevenoaks Weald. Life there was happy. They enjoyed this more rural location, and the freedom of the outdoors helped to keep Thomas' depression at bay. His reputation as a writer and critic grew – one whose favourable opinion could cement the reputation of any writer. Many subsequent authors have commented on the quality of his criticism; Vernon Scannell, for example, compliments Thomas for his instinctive understanding of poetry and his appreciation of technique.

In 1908, life at the farm ended when its owner retired, and the family moved to Hampshire. Here Helen taught at Bedales School which the children attended, whilst Edward continued his writing and reviewing. It was not until 1914, after forming a friendship with the American poet Robert Frost, that Thomas began to write the poetry upon which his fame now rests. In 1915, with the country at war he enlisted and was killed in action in Arras two years later.

Helen heard the news whilst living in Otford, near Sevenoaks. Her two books, *World Without End* (1926) and *As It Was* (1931), are moving accounts of her relationship with Thomas and his life as a writer.

One author who benefited particularly from Thomas' patronage was W. H. Davies (1871–1940). Thomas had reviewed Davis' writing and on discovering that the latter was living in near destitution in London, invited him to live in Kent, setting him up in a small cottage close to Else's Farm in nearby Egg Pie Lane, Hildenborough. The Thomas children would often walk across the fields to the cottage taking food prepared by Helen.

Henry Davies had begun life in Newport, Wales, but in 1871, at the age of twenty-two, he sailed for America. He spent the next six years travelling across the USA and Canada,

Ivy House.

Bearsted Green.

Edward Thomas, *c.* 1912.

Typical view across the Kentish Weald, a landscape important to both Helen and Edward.

jumping freight trains, and making money whenever he could get a few days' casual labour. This freewheeling lifestyle came to an end in 1899, when, attempting to board a train heading for the Klondike gold fields, he tripped, crushing his right leg beneath the wheels. A below-the-knee amputation meant he was forced to return to Britain.

In London, he began to write poetry, using the last of his resources to self-publish a volume entitled *The Soul's Destroyer* in 1905. Thomas' help and support after the move to Kent were invaluable; Thomas even arranged for a local wheelwright to make a new wooden leg for his friend, the bill describing it as a 'novelty cricket bat'. In 1908, Davies published the successful *Autobiography of a Supertramp* about his years in America and went on to produce several other volumes of poetry and prose.

After the Thomas family left for Hampshire, Davies remained in Kent, renting a series of houses in Sevenoaks before moving to London in 1914. Upon learning of Edward's death, he wrote *Killed in Action* in memory of the 'man who loved this England well'. Davies returned to Sevenoaks with his wife after their 1923 marriage before spending the rest of his life in Gloucestershire. The work for which he is probably best known is his poem 'Leisure' with its memorable opening couplet, 'What is this life if, full of care/We have no time to stand and stare'.

His poems are far removed in both subject matter and style from those of the great Modernist poet T. S. Eliot (1888–1965). An American, Eliot had moved to England in 1914,

W. H. Davies.

becoming a British citizen in 1927. *Prufrock and Other Observations* was published in 1917 and met with a mixed reception, so profoundly different was it from anything that had gone before. *The Waste Land* followed in 1922 and set Eliot firmly on the path to becoming one of the most important poets ever to write in English.

Divided into five sections, this lengthy poem confuses the reader with its shifting narrative voices, and changes of time and place. It is full of symbols, literary allusions, even slipping into other languages in places – and it changed poetry for ever. For many it articulates the desolation and disillusion brought about by the First World War, with E. M. Forster describing it as 'a poem of horror'. Eliot worked on the poem during a prolonged stay in Margate in 1921, where he had gone to recover from what seems to have been some sort of mental collapse brought on by the death of his father and the end of his first marriage.

By the 1930s Eliot had begun to write plays, and in June 1935, *Murder in the Cathedral* was commissioned for the annual Canterbury Festival.

In the same year that *The Waste Land* first appeared, the actor and writer Russell Thorndike (1885–1972) performed in a stage adaptation of his own novel *Dr Syn, A Tale of the Romney Marsh*. Published in 1915, the book tells the story of a seemingly ordinary eighteenth-century vicar in the quiet seaside town of Dymchurch, who leads a clandestine double life.

Thorndike was born in Rochester where his father was a cathedral canon. Educated at the city's King's School, he then embarked upon an acting career. He enlisted at the

The shelter in Margate where Eliot wrote part of *The Waste Land.*

Eliot's verse drama *Murder in the Cathedral* was first performed in the Chapter House of Canterbury Cathedral in 1935.

outbreak of war in 1914 but was so severely wounded at Gallipoli the following year that the army discharged him. He returned to the stage, touring alongside his sister, Sybil, who became one of the country's most revered actresses.

The popularity of Dr Syn led to Thorndike responding to requests for more of his adventures and in 1935, *Dr Syn on the High Seas* was published. Another six novels followed, all 'prequels' to the original, telling the adventures of a man who is a clergyman by day and a smuggler by night.

Thorndike was a regular visitor to his mother's home in Dymchurch and often worked upon the stories during these visits.

In 1964, he allowed the parish council of St Peter's and St Paul's Church to organise a *Day of Syn*, to raise money for repairs to the building. Over the years, this has grown into a bi-annual event, taking place for three days over the August Bank Holiday weekend. Locals dressed as characters from the novels parade through the town and take part in historical re-enactments such as battles between smugglers and excise men.

In the early 1920s, two friends came to Dymchurch on holiday and spent hours cycling around the Romney Marshes. One of them was a young Noel Coward (1899–1973), hoping to find a quiet location where he could focus on his developing career as a writer. In the village of St Mary-in-the-Marsh he found a cottage next to the Star Inn and moved in soon after. In 1926, he was successful enough to buy Goldenhurst Farm in Aldington, carrying out major works which saw the farmhouse and various outbuildings joined together as one extensive property.

Coward enjoyed writing with his back against a gravestone in the churchyard opposite his Romney Marsh cottage.

Coward by Hythe's Royal Military Canal, c. 1930. (Copyright theromneymarsh.net)

Goldenhurst was requisitioned by the Army at the start of the Second World War, so Coward set up home at White Cliffs house in St Margaret's Bay, which he also grew to love. Coward eventually returned to Goldenhurst in 1951, writing in his diary that the 'house and land seemed to envelop me in a warm and lovely welcome'. In 1956, however, the expense of maintaining the property saw him leave Kent for good to set up home in Jamaica.

White Cliffs had hosted many of Coward's literary and theatrical acquaintances, including one of his closest friends, Ian Fleming (1909–64). Indeed, Fleming's sister-in-law was Celia Johnson who plays Laura in *Brief Encounter*. The author of the James Bond novels was no stranger to Kent; it has been suggested that the 007 bus from London to Dover may have been the inspiration for Bond's agent number. A keen golfer, he had played regularly at Royal St George's in Sandwich since the 1930s, becoming club president only the day before his death.

Fleming had bought White Cliffs from Coward in 1951 and lived there until 1957, before coming to live at the Old Palace in Bekesbourne in 1960, which later became the home, appropriately, of a deputy head of MI5. His familiarity with the county is evident in novels such as *Moonraker* (1955) where Bond prefers the roads around Chilham and Canterbury to those of Ashford and Folkestone as he heads towards the villainous Hugo Drax's lair in Kingsdown, just down the coast from Deal. Goldfinger and Bond encounter one another at Royal St George's and in his children's story *Chitty Chitty Bang Bang*, the flying car takes to the skies over Goodwin Sands. Fleming imagined the unique vehicle

Coward wrote some of his most popular works at White Cliffs including *Brief Encounter* and *Blithe Spirit*.

after visiting the home of racing driver Louis Zborowski, who lived at what is now Higham Park, Bridge.

Fleming was a close friend of Patrick Leigh Fermor (1915–2011) who may well have served as a model for the character of Bond. In *A Time of Gifts* (1977) Fermor remembers being moved by the 'intoxicating antiquity' of King's Canterbury where he was a pupil until being expelled in 1931 after becoming rather too friendly with the local grocer's daughter, eight years his senior. At the age of eighteen, he walked from the Hook of Holland to Istanbul which he describes in *A Time of Gifts* and *Between the Woods and the Water*. Fermor did not care to be thought of as a travel writer, but his books are amongst the finest of their type.

He spent two years as a Resistance fighter in Greece as part of SOE operations during the Second World War, which he documents in *Abducting a General* (2014) although the account by his second- in-command, Bill Moss, entitled *Ill Met by Moonlight* (1950), had told the story many years earlier.

Fermor spent a lot of time in Greece, as did Lawrence Durrell (1912–90) who had been educated at St Edmund's School, Canterbury. He moved to Corfu with his family in 1935, a period of his life immortalised by his younger brother, Gerald, in *My Family and Other Animals*. Today Lawrence is best known for *The Alexandria Quartet* novels, set in Egypt during the Second World War.

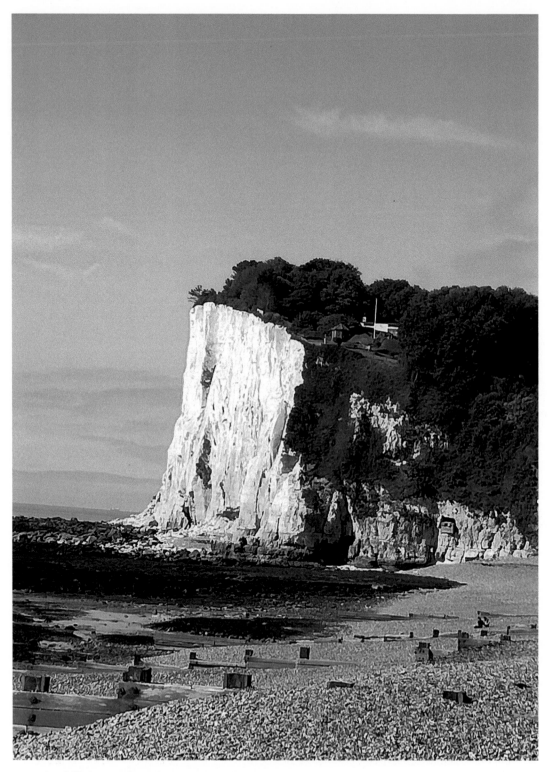

The cliffs at Kingsdown, home to the evil Drax.

According to his fictional obituary in *You Only Live Twice*, the young Bond lived with an aunt in Pett Bottom, in a cottage near to the Duck Inn. Fleming worked on the book seated on a bench in the pub's garden.

Eric Ambler (1909–98), whose books about the murky world of espionage rank amongst the finest early examples of the modern thriller novel, was also a regular visitor to White Cliffs during the war. The heroes of his stories are not professional agents but amateurs who are forced by chance into dangerous situations not of their making. Ambler was also a successful screenwriter, his most notable scripts being for the war film *The Cruel Sea* and *A Night to Remember*, the story of the *Titanic*. After a short spell in Hollywood, Coward leased Ambler a house in St Margaret's Bay on condition that he return to writing novels; *Judgment on Deltchev* (1951) was the result.

Ambler's importance to the genre has been acknowledged by many thriller writers, including Frederick Forsyth. Born in Ashford in 1938, he gained a scholarship to Tonbridge School, going on to join the *Kentish Express* as a junior reporter. He only spent six weeks there before being called up for National Service where he distinguished himself as one of the RAF's youngest ever pilots. He returned to journalism, covering the Biafra crisis for the BBC in the late 1960s. His first novel was *The Day of the Jackal* (1971), swiftly followed by *The Odessa Files* (1972) and *The Dogs of War* (1974), all of which were later made into successful films. In a 2014 interview with BBC Kent, Forsyth spoke of his love of villages such as Smarden and Pluckley: 'the sort of Kent that H.E Bates wrote about ... Pa and Ma Larkin's Kent'.

Pluckley is in the heart of Larkin country.

H. E. Bates (1905–74) himself had moved to Kent when he came to live in a house called The Granary in Little Chart near Charing soon after he married in 1931, and where he lived for the rest of his life. Already a writer, during the Second World War he was commissioned into the RAF with the unusual task of writing morale-boosting short stories about dauntless pilots and their courageous exploits. Many appeared in the *News Chronicle*, penned by mysterious Flying Officer X. He also wrote the novel *Fair Stood the Wind for France* (1944) during this time.

Bates explained that his most famous characters came about due to a chance encounter outside a Kentish village shop where he observed a 'perky, sprightly' man and his buxom wife accompanied by their six children, all enjoying 'colossal multi-coloured iced creams' at the same time as eating bags of crisps, all paid for from a wad of notes fastened by elastic bands. The Larkins had arrived, first appearing in *The Darling Buds of May* (1958) followed by four more novels about their exploits in the 'perfick' rural Kent of the 1950s and 1960s. Various television adaptations of the stories have ensured their continued popularity.

Writer and Illustrator Mervyn Peake (1911–68) lived briefly in Smarden in the early 1950s. He is best known for the three books that make up the *Gormenghast* trilogy, set in the fantastical, pseudo-medieval world of Castle Gormenghast, very different to the Larkins' rural idyll. The series has been praised as amongst the best of all novels in its genre.

Serialised in *Everybody's Magazine* in 1958, *The Darling Buds of May* was illustrated by Leslie Illingworth.

Chartwell near Westerham became the home of Winston Churchill (1874–1963) in 1922, after he was captivated by the views across the Kentish hills on his first visit there. Revered as Britain's wartime Prime Minister, Sir Winston started out not as a politician but as a journalist who published his first book in 1898, telling the story of his experiences on India's Northwest Frontier. By 1900 he had published four more and remained a writer all his life, with the six-volume *The Second World War* (1948–53) and the four-volume *History of the English-Speaking Peoples* (1956–58) amongst his major works. He was awarded the Nobel Prize for Literature in 1953 'for his mastery of historical and biographical description'. The award also acknowledged the power of his stirring wartime speeches.

Another Noble Laureate to have Kentish associations is William Golding (1911–93). From 1938 to 1940 he lived in Maidstone, where he taught both at the Grammar School and Maidstone Prison. His employment at the latter was terminated in somewhat mysterious circumstances although in later life, Golding put it down to the fact that he was a heavy-drinking womaniser with left-wing tendencies.

After the war, he returned to teaching whilst also trying his hand at writing. Publishing companies seem to have been about as impressed with his efforts as Maidstone Prison had been years before. His first novel was described by Faber & Faber as 'pointless', but after due consideration they relented and in 1954, *The Lord of the Flies* was published. The story of a group of boys left to fend for themselves on a deserted island remains one of the most well-read of all post-war novels. *Pincher Martin* (1955) and *The Inheritors* (1956) are amongst the many works that followed this first success, with the Noble Prize for Literature being awarded to Golding in 1983.

Statue of Churchill in Westerham, near Chartwell.

7. Children's Writers

Frances Hodgson Burnett (1849–1924) spent her early life in Manchester before making the long journey to Tennessee in 1863 to live with an uncle following her father's death. She began writing to help the family's perilous finances and in 1885, *Little Lord Fauntleroy* was serialised in *St Nicholas*, a children's magazine. Published in a single volume soon after, it was a huge success both in America and Britain, giving her sufficient financial freedom to allow her to divorce her unsatisfactory husband in 1898, after years apart. *The Washington Post* promptly condemned her for her 'advanced ideas' about women's rights which may have been what prompted her to come back to England where she rented Great Maytham Hall in Rolvenden.

On first arriving there, she had been led by a robin to an ivy-obscured door leading to a neglected walled garden dating from the 1720s. Here was the inspiration for one of the best loved of all children's stories, *The Secret Garden* (1911). The orphaned Mary Lennox arrives in Yorkshire, leaving everything she has ever known behind in India. Lonely and bewildered, her life is given new meaning when she too follows a robin to a forgotten garden.

The 1971 film of *The Railway Children* was filmed in Yorkshire, perhaps leaving its viewers with the idea that the book's author was herself from that county. In fact, Edith

Bluebell woods near Maytham, the only place Burnett 'ever felt was home'.

Nesbit (1858–1924) spent a considerable time in Kent and the inspiration for her most famous book most likely came from her life there as a girl.

After the death of her father when she was four, her mother left London taking Edith and her sister Mary on a European tour in the hope of curing Mary's tuberculosis. After their return to England, they moved to Halstead, just outside Sevenoaks. A railway line ran along the bottom of the garden and Nesbit used to walk to Chelsfield station to watch the construction of the tunnel connecting Chelsfield and Knockholt.

At the age of eighteen, she met Hubert Bland, marrying him when she was already seven months pregnant, not knowing until after the wedding that another woman was also expecting his child. Bland, indifferent to both women it seems, carried on living with his mother, leaving Edith to support herself and her baby with little help from him. She rose to the challenge by writing poems and children's stories for magazines, just as the mother in *The Railway Children* does after her husband's wrongful imprisonment.

In 1886, the faithless Hubert announced to Edith that he was expecting a child with her friend Alice Hoatson and demanded that she move in with them. Fearing total abandonment, she accepted his demands, and by 1899, this unusual menage had moved to Well Hall in Eltham. Nesbit continued to support the family with works such as *The Treasure Seekers* and *Five Children and It*. Regardless of the awkwardness of her domestic arrangements, Nesbit loved to entertain and authors such as H. G. Wells and

Locomotive No. 5775 which featured in the 1970 film version of *The Railway Children*. (Courtesy of Alan Wilson)

George Bernard Shaw were regular visitors. Not to be outdone by Hubert, she too had a succession of lovers, including a doomed infatuation with Shaw.

Bland died in 1914 and his death encouraged her to move back to Kent, this time to the Romney Marshes. She married a long-time friend, Tommy Tucker, in 1917 and they settled into life in the tiny village of St-Mary-in-the-Marsh. Here she met Noel Coward when he came to live in the village and the two formed a friendship. He had loved her books from childhood and when he died in far-away Jamaica in 1973, a copy of her book *The Enchanted Castle* was on his bedside table.

Despite being written during what we like to think of as the golden Edwardian era, Nesbit's characters often have to face up to difficult truths. Children such as Bobby, Phyllis and Peter in *The Railway Children*, for example, are forced to confront financial hardship, illness and injustice. In *The Story of the Treasure Seekers*, the Bastable children live with the loss of their mother and the financial insecurities faced by their father. Nesbit's influence upon children's literature has been a lasting one; C. S. Lewis, Jacqueline Wilson and J. K. Rowling have all acknowledged her impact upon their own stories, where children are often thrown back upon their own resources in order to survive.

In November 1920, an anonymous brown bear dressed in blue sweater and grey trousers appeared for the first time in a *Daily Express* cartoon story called *The Little Lost Bear*.

THIS TABLET WAS ERECTED BY HER MANY FRIENDS IN MEMORY OF
EDITH M. NESBIT
1858 · 1924
WHO DELIGHTED THE HEARTS OF SO MANY CHILDREN BY HER BOOKS AND WHO SPENT THE LAST YEARS OF HER LIFE IN THIS PARISH
I will dwell among my children

Nesbit is buried at St-Mary-in-the-Marsh, remembered by a plaque in the church.

He was the creation of Canterbury-born artist Mary Tourtel (1874–1948), who had been asked by her husband, an assistant editor on the paper, to invent a comic strip to compete with the *Mirror's* popular *Pip, Squeak and Wilfred*.

Tourtel attended Simon Langton Girls' School before studying at Canterbury's Thomas Sidney Cooper School of Art (now part of the University of the Creative Arts). She had illustrated children's books early in her career, including *The Three Little Foxes* (1903) and *The Strange Adventures of Billy Rabbit* (1908) and turned again to the animal world when seeking inspiration for this latest commission.

The early stories about the little brown bear did not cause much of a stir, so Tourtel made some changes. She dressed him in more eye-catching yellow trousers and matching scarf, with a bright red jumper. He turned from brown to white and most importantly, he was given a name – Rupert.

"My cuckoo's back again – hooray!
He didn't really go away!"

Rupert the Bear's centenary was commemorated on a set of Royal Mail stamps in 2020.

His popularity now grew, with eager young readers following Rupert's exploits in Nutwood, alongside friends such as Podgy Pig, and Reggie and Rex Rabbit. In 1935, Tourtel was forced to give up work as her eyesight deteriorated and the strip was taken over by one of Enid Blyton's illustrators, Alfred Bestall. In 1936 the first *Rupert Bear* annual was published, with Bestell continuing to create the cartoon strip and annuals until 1965. Asked where he thought Nutwood was to be found, he told a biographer that in his illustrations it was a mixture of several landscapes, including that of the Weald between Kent and Sussex. One hundred years later, Rupert's adventures still appear in the *Daily Express*, his popularity enhanced by several animated television versions of the stories.

Tourtel herself died in Canterbury in 1948, having collapsed on the High Street with a brain tumour. She had lived her whole life in the city, her final address being 63 Ivy Lane. The creator of one of the most recognisable figures in British children's literature is buried in the graveyard of St Martin's Church, with a simple headstone that makes no mention of Rupert at all.

From 1908 to 1940, readers of the children's comic *The Magnet* were entertained by the escapades of Billy Bunter, written by Frank Richards (Charles Hamilton, 1876–1961) who from 1926 until his death lived at Rose Lawn, Kingsgate near Broadstairs. Although the adventures of the lazy, obese, conceited Owl of the Remove can feel dated today, there is something about his optimistic outlook on life

The Beaney House of Art and Knowledge contains a tribute to Rupert and his creator.

that still holds an appeal. After the comic's closure, Bunter's escapades continued in a series of novels.

The series of thirty-nine books collectively known as the *Just William* stories were published between 1922 and 1970 and chart the adventures of William Brown and his gang, the Outlaws. The scruffy, anarchic schoolboy was the creation of Lancashire born Richmal Crompton (1890–1969) who had been a teacher at Bromley High School, when the town was still officially in Kent. A bout of polio in 1923 left her without the use of her right leg and, obliged to give up her teaching career, she began to write full time. Although she wrote novels for adults, it is the William stories that have ensured her fame, helped by their many TV and radio adaptations.

Growing up in Chatham and Canterbury, Rosemary Sutcliffe (1920–92) became fascinated by the Roman and Celtic legends her mother would tell her and they became the inspiration for much of her writing. Her series on Roman Britain beginning with *The Eagle of the Ninth* (1954) and ending with *The Lantern Bearers* (1959) brings this long-ago world vividly to life.

Clive King (1924–2018) had begun writing whilst a pupil at the King's School, Rochester, where he produced articles for the school magazine. His work with the British Council involved extensive travels but it was memories of the quarry next to his childhood home

Dover Castle, described by Bunter as a 'frightfully historical place'.

at Oliver's Farmhouse in Ash, on the North Downs, that inspired the most famous of all his books. Published in 1963, *Stig of the Dump* explores the friendship between Barney and Stig, the caveboy he meets in a dump on the edge of a Kent chalk pit.

The 1963 edition of the novel was illustrated by Edward Ardizzone (1900–79), an artist who first visited Kent on a family holiday spent in Eynsford. In the 1930s, visits to his brother's house in Kingsdown inspired the setting for his own *Little Tim* series of books. In 1966, he bought a house in Rodmersham and he draws upon Kent for many of his illustrations in books such as Nesbit's *Long Ago When I Was Young*, and *My Uncle Silas* by H. E. Bates.

Above: Even the offer of a trip to Sevenoaks and beautiful Knole Park cannot tempt Barney away from his adventures with Stig.

Right: Rodmersham village.

8. The Present

Born in 1943, one of the most important of all recent children's authors, Michael Morpurgo, boarded at King's School Canterbury, before going on to join the army. He decided, however, that a military career was not for him and left to train as a teacher. He writes on his website that he 'ended up teaching in a little village primary school in Kent, at Wickhambreaux, where I ran out of other people's stories to read, so started making up some of my own'. Those stories now include such books as *War Horse* (1982), *Why the Whales Came* (1985), *The Butterfly Lion* (1996) and *Private Peaceful* (2003).

Together with the poet Ted Hughes, he created the position of Children's Laureate, awarded every two years to a 'writer or illustrator of children's books to celebrate outstanding achievement'. Morpurgo himself was the third Laureate from 2003 to 2005.

The Canterbury War Horse was placed in the Cathedral Precincts in 1918 to commemorate the centenary of the end of the First World War.

Jane Gardam's first book was a children's novel, *A Long Way from Verona* (1971), published when she was forty-three. She has gone on to write other books for children, including *The Hollow Land* (1981) which received the Whitbread Children's Book Award. Her adult novels have also been prize-winners, with *Old Filth* (2004) being particularly well-regarded. Gardam has owned a home in Sandwich for many years and has been involved in the creation of the town's Arts Festival.

William Horwood has also written for both adults and children. Born in 1944, he grew up in Deal, attending Roger Manwood School in Sandwich. After an early career as a journalist, he decided to become a writer, inspired by the memory of reading *The Secret Garden* as a child. *The Boy with No Shoes* (2004) is the compelling fictionalised autobiography of his troubled childhood in the coastal town. Deal also plays a prominent role in *The Stonor Eagles* (1982). He is best known for the *Duncton Wood* (1980–93) series of novels as well as for sequels to *The Wind in the Willows* (1993–99).

Former primary school teacher Wendy Cope (1945–) grew up in Erith before attending Oxford University. Her first book, *Making Cocoa for Kingsley Amis* (1986), was a huge success, thanks to its 'witty lyrics and pitch-perfect parodies'. Subsequent collections have cemented her reputation as one of the wittiest and most accessible of all modern poets.

Today, the county continues to produce writers across a variety of genres. Graduates of the University of Kent David Mitchell and E. L. James have found fame with novels as diverse as Mitchell's *The Cloud Atlas* (2004) and *The Bone Clocks* (2014) and James' infamous *Fifty Shades* trilogy. Describing it as a 'wonderful ... eccentric little place', experimental novelist Nicola Barker was inspired to move to Faversham by reading *Arden of Faversham* and books such as *Darkmans* and *Wide Open* have Kentish settings. In 2015, Julie Wassmer published *The Whitstable Pearl Mystery*, set in the town where she herself lives. It became the first in a series of books, all set in recognisable East Kent locations.

There are many other authors who have found both inspiration and a home in the county and a work of this size cannot hope to mention them all. It can only touch upon the lives and achievements of some of those whose writing has been shaped by the landscapes and people of Kent over the last thousand years. The history of literature in Kent is, in many respects, the history of English literature itself. It should be celebrated.

Bibliography

Rochestercathedral.org
Canterburycathedral.org
Britishmuseum.com
The Poetry Foundation
The Victorian Web
Visittunbridgewells.com
Kentliterature.com
Historyextra.com
Poemhunter.com
Visitgravesend.co.uk
The Romneymarsh.net
Dover Museum website
BBC.co.uk
Charlesdickens.info.com
Jane Austen Society website
Wikipaedia
Edward-thomas-fellowship.org
Dickens; London into Kent Peter Clark (The Armchair Traveller 2013)